IMAGES
of America

CATALINA BY AIR

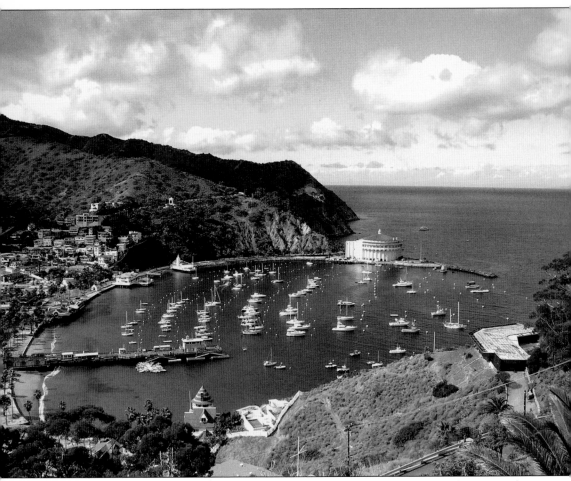

Catalina Island is an enchanting Pacific isle just off the coast of Los Angeles in Southern California. The island has a fascinating history dating back over 7,000 years. Its recent history includes the development of the world-renowned resort community of Avalon and the millions of visitors who have been lured by its charm. One of the most interesting aspects of this history is transportation. Since Catalina Island lies in the middle of the ocean, how did visitors first access the island and how long did it take? Crossing the San Pedro Channel by steamship was the most common way for years, but soon the ships were being passed overhead by seaplanes and airplanes. The channel crossing could be quite exciting and was a memorable part of the Catalina experience. Join us as we embark on a voyage by air to Catalina Island.

ON THE COVER: In 1931, the Santa Catalina Island Company, under the direction of Philip K. Wrigley, built the Catalina Airport at Hamilton Beach and started Wilmington-Catalina Airline. The small airport was built at Hamilton Cove and had a unique turntable system for turning the seaplanes in tight quarters. The terminal building of the airport was built in a Spanish Colonial style and included a ticket office, Catalina tile–lined waiting room, a refreshment counter, and a lovely garden waiting area. Wilmington-Catalina Airline operated Loening Amphibians and Douglas Dolphin aircraft. (Courtesy Catalina Island Museum.)

IMAGES
of America

CATALINA BY AIR

Jeannine L. Pedersen
Catalina Island Museum

ARCADIA
PUBLISHING

Copyright © 2008 by Jeannine L. Pedersen, Catalina Island Museum
ISBN 978-0-7385-5936-0

Published by Arcadia Publishing
Charleston SC, Chicago IL, Portsmouth NH, San Francisco CA

Printed in the United States of America

Library of Congress Catalog Card Number: 2008921579

For all general information contact Arcadia Publishing at:
Telephone 843-853-2070
Fax 843-853-0044
E-mail sales@arcadiapublishing.com
For customer service and orders:
Toll-Free 1-888-313-2665

Visit us on the Internet at www.arcadiapublishing.com

This publication is dedicated to all those who played a role in Catalina's aviation history: to the early air pioneers, airline owners, pilots, and employees. Also to the many residents and visitors who have fond memories of riding the seaplanes and airplanes across the channel.

CONTENTS

ACKNOWLEDGMENTS

The photographs, brochures, and postcards in this volume represent significant aspects of Catalina Island history. The Catalina Island Museum is dedicated to collecting, preserving, and interpreting every aspect of Catalina's unique history. Since the museum opened its doors in 1953, we have accepted over 100,000 artifacts from hundreds of generous donors, and these artifacts are used for exhibition, research, educational purposes, and publication. This publication would not be possible without the generosity of these donors and the assistance of the museum staff and several community members. I would like to personally thank Jessica Morales and Stacey Otte for their excellent assistance with research and editing. Thank you to John Phelps, Doug Bombard, John Moore, Joey Hernandez, Irene and Frank Strobel, Hugh T. Smith, David T. Johnston, and Sandra Putnam for sharing their wonderful memories and photographs. Thank you to the Santa Catalina Island Company, the Briles family, Allan and Laurie Carter, Jay Guion, Dennis Buehn, and Al Gordon for contributing photographs for the book. A special thank-you goes to Rex and Carole Cotter for sharing stories and memories they collected from residents and visitors. And a special thank-you goes to Roger Meadows for your enthusiasm, support, and research assistance. The majority of the images in this book are from the extensive collections of the Catalina Island Museum. Additional images from private collections are noted otherwise.

FOREWORD

This volume marks our third publication with Arcadia Publishing. Our first was a general history of Catalina Island told primarily through images from our extensive collection. Knowing we had only just skimmed the surface of the collection for that book, we readily signed on for a second volume with Arcadia. We initially thought to focus on both air and water transportation to the island, but our collection of steamship photographs and ephemera was so rich, we decided to narrow our focus to *Catalina by Sea*. The book was greeted with enthusiasm, and it was not a hard decision to agree to this third volume, focused on Catalina's rich history of air transportation.

Once again, our curator, Jeannine Pedersen, has spent countless hours researching this topic, combing through our archives, and conducting meetings and interviews with several longtime residents of the island and former employees of various airlines. Her research was assisted by several volunteers who painstakingly read through our local papers and explored the online archives of the *Los Angeles Times*. In this process, a wonderful resource of materials has been accumulated and organized that will serve researchers for generations to come.

Catalina's aviation history is a source of pride for our community. The island was the location of several aviation firsts—the longest over-water flight, the first regular passenger service, and the first dirigible passenger service in the world. Other fascinating aspects of our aviation history are a seaplane turntable system developed by Philip K. Wrigley and the shaving off of mountaintops for the creation of an airport, which is still in use today.

We hope you will enjoy this exploration of a very unique and special part of our history. No doubt many of you will have some of your own memories of flying to Catalina. I certainly wish I could have been here during the heyday of the seaplane era and have enviously listened to people's stories of the roar of the planes' engines filling Avalon Canyon as they made their approach to land just outside the bay. What a remarkable sight that would have been. It is no wonder Catalina's aviation history has so many devotees.

We would love to hear your stories and hope you will share them with us. Please visit our Web site at www.catalinamuseum.org, and you will find a link to share a story with us and be able to read others' reminiscences.

The Catalina Island Museum's mission is to collect, preserve, and share the artifacts, memories, and stories of our rich and varied past. Our collections, numbering over 100,000 individual items, include the most comprehensive collection of Island Gabrielino artifacts in the world, a complete run of two local newspapers, over 10,000 photographs and negatives dating from the very first days of the founding of Avalon, a significant collection of locally made Catalina pottery and tile, and so much more. Postcards, home movie footage, souvenirs, boat models, outboard motors, an early Spanish coin, paintings, books, and much more help us to share Catalina's many stories with the public.

Annual programs and exhibits include a classic silent film screening, Catalina pottery and tile exhibition, holiday open house at the former Wrigley mansion, exhibition of beautiful Catalina plein air art, and live telethon broadcast locally and online. We also host hundreds of local and

mainland students and other groups and offer twice-weekly walking tours through Avalon. These are just some of the ways that we show that "history's never been this much fun!"

The Catalina Island Museum is a private nonprofit organization, and we rely on our members and supporters for the funds to do our work in preserving the stories, memories, and artifacts of our past. Please consider supporting our vital work. Donations are tax-deductible and can be sent to: Catalina Island Museum, PO Box 366, Avalon, CA 90704. More information about supporting our work can be found at www.catalinamuseum.org.

Happy reading!

—Stacey Otte
Executive Director
Catalina Island Museum

One

THE PIONEERS

Catalina Island's aviation history took flight on May 10, 1912, when a young Glenn L. Martin strapped a barometer to one knee and a compass to the other, wrapped an inflated bicycle inner tube around his body, and climbed aboard his handmade box-kite flying machine. Martin constructed the biplane of wood with airtight compartments and a single pontoon. Martin planned to fly his biplane from Balboa Island in Newport Bay to Catalina Island. As he took off, Martin ascended to 2,000 feet into a thick bank of fog. Within six minutes, Martin and his plane disappeared from sight to the crowd below who assembled to watch what they perceived as a suicide mission. According to an article printed in the *Los Angeles Times* on May 11, 1912, "Martin rose above the fog and came out into bright sunlight. He rose 3,500 feet and won the name of mariner of the air in that flight. Below him was a desert of gray fog. Not a bit of land or water to be seen. He had nothing but sky above and nothing but fog beneath. As a sailor in the midst of a great ocean is guided by compass, so was Martin." After 25 miles, Martin shut off his motor and descended gradually. Pressing through the fog bank, he soon came into view of the blue sea, and a few miles off in the distance was Catalina Island.

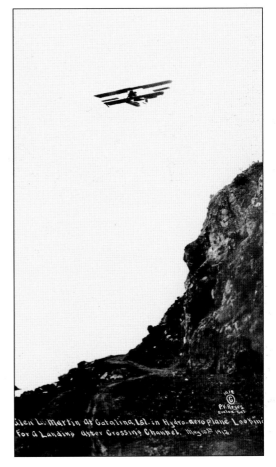

Glen L. Martin at Catalina Isl. in Hydro-aeroplane Looking for a Landing after Crossing Channel. May 10 1912.

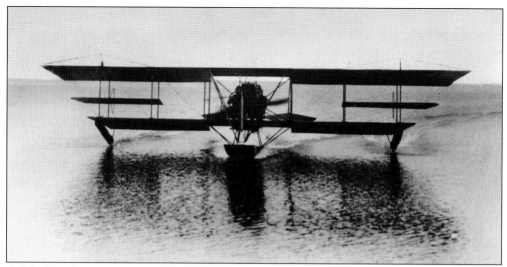

Suddenly Martin's flying machine appeared above the hillsides of Avalon and quickly aroused interest from local residents. As the biplane glided down to touch the water in Avalon Bay, an enthusiastic crowd gathered on the beach. The successful flight proved to be the longest over-water flight in the world at the time, flying 34 miles in 37 minutes, and was also the first sea landing in history. It was banner day for aviation history and Catalina Island.

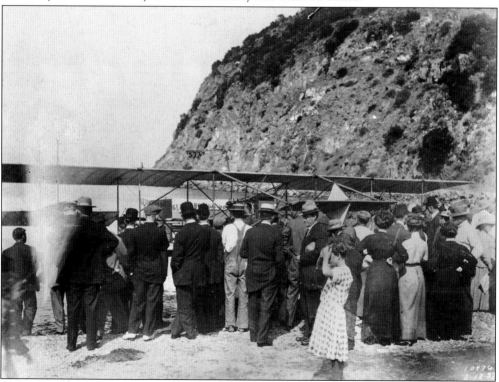

The crowd that gathered at South Beach in Avalon Bay to greet Martin surged forward to help drag the plane up on the beach. While they pulled the plane across the pebbles, the fragile pontoon was torn. Martin repaired the pontoon with a crude patch while answering many questions from the crowd about his flying machine.

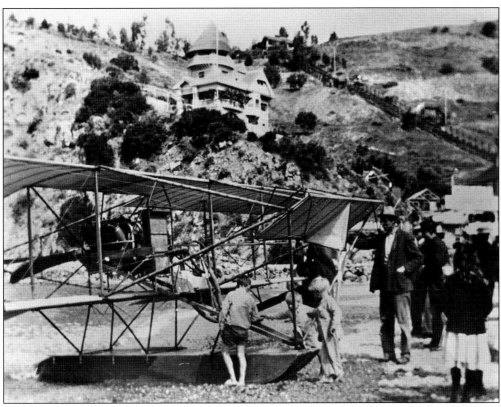

After repairing his pontoon, Martin swung his aircraft into the wind for the return takeoff and departed the beach in Avalon with the well wishes of every resident and visitor. Just as he was airborne, the patch on the pontoon gave way, so he followed the steamer lane on his return trip where he would have a better chance of being picked up in case of an emergency landing. Fortunately, Martin landed his plane without incident, putting it down close to shore so he would be in shallow water in case the damaged pontoon failed to keep the plane afloat.

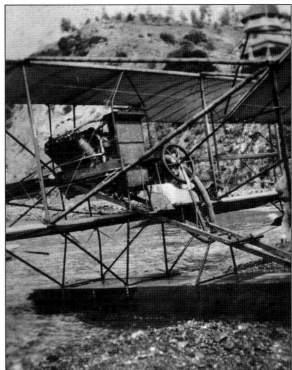

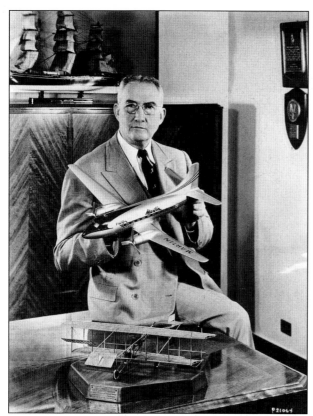

Glenn L. Martin continued to make aviation history throughout his life. He started as a young business owner in Santa Ana, California, operating a Ford Maxwell dealership and built his first airplanes in collaboration with the mechanics in his auto shop. He taught himself to fly in 1909 and quickly became an aviation pioneer. In 1912, Martin formed the Glenn L. Martin Aircraft Company and directly managed the company for the next 40 years. During that time, his company was the senior aircraft manufacturer in the United States.

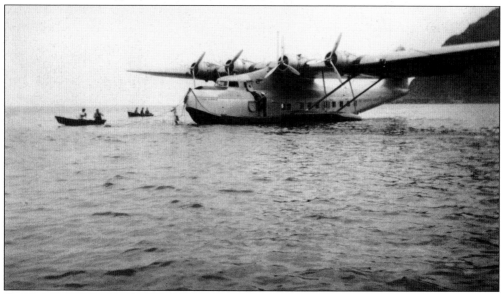

On May 10, 1937, precisely 25 years after Martin's historic flight to Catalina Island, he returned to reenact the famous flight in the Martin China Clipper. The China Clipper was one of Martin's most famous aircraft designs and the first airplane to enter transoceanic commercial service under the auspices of Pan-American Airways. The great China Clipper made the cross-channel flight in 12 minutes—a third of the time it took for Martin's original flight.

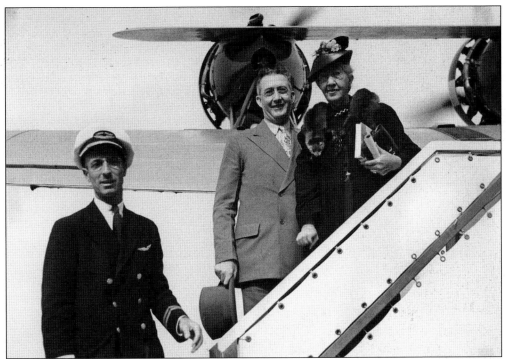

Glenn Martin was accompanied by his mother, Mrs. Minta DeLong Martin, on the commemorative flight to Avalon Bay. Martin always attributed his mother with providing the encouragement to pursue his aviation dreams. Martin and his mother were greeted enthusiastically by a large crowd who gathered on the beach in Avalon just as residents did 25 years earlier.

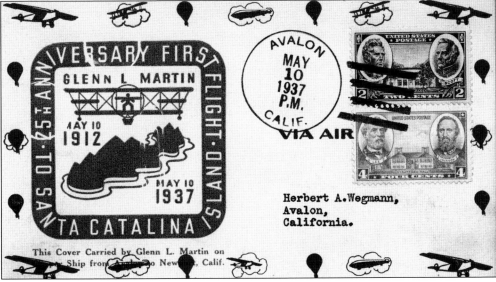

Adding to the importance of the commemorative flight, the U.S. Postal Service gave Martin permission to carry mail aboard the China Clipper that day. Special mailing covers were designed bearing a cachet in commemoration of the 25th anniversary of Glenn Martin's flight to Santa Catalina Island in 1912. Cachets were applied to mail received at both Avalon and Newport and were a desirable souvenir of the day.

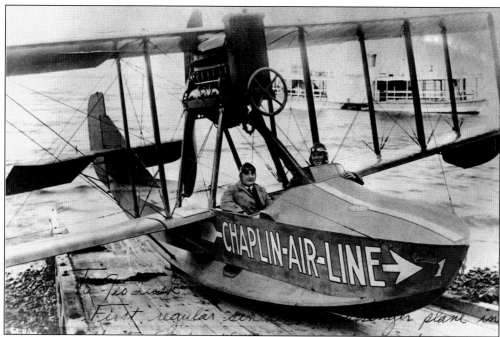

In the several years that followed Glenn Martin's historic flight to Catalina Island in 1912, aviation technology quickly expanded, and it was not long before the first air passenger service was introduced to Catalina. Syd Chaplin, half-brother to the famous Hollywood comedian Charlie Chaplin, began the first seaplane service between Wilmington, California, and Catalina Island with a Curtiss MF "Seagull" three-passenger flying boat in 1919.

Syd Chaplin came to Los Angeles in 1919 to manage his brother's career, but he longed to venture into the world of aviation and quickly got his chance. He soon met Emory Rogers, who had been recently discharged from the U.S. Army Air Corps and had similar ambitions as that of Chaplin to operate a commercial aeronautical business. The two men founded the Syd Chaplin Aircraft Company in 1919 with Rogers serving as general manager.

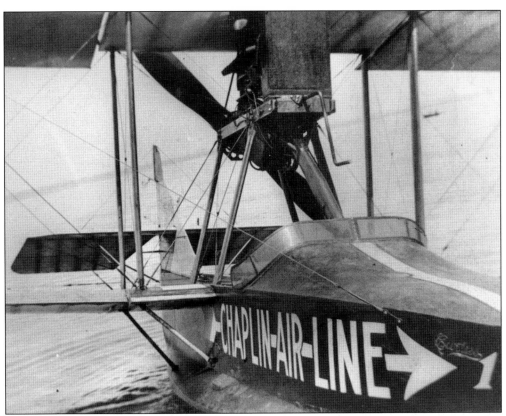

Emory Rogers left for New York to secure a Curtiss airplane dealership for the Los Angeles area while Chaplin was busy leasing land for an airport in Los Angeles and obtaining the rights to land at Catalina Island. Chaplin received permission from William Wrigley Jr., who had recently purchased Catalina Island, to land his aircraft at Avalon and leased land from the Marine Equipment Company in Wilmington, California, to be used as a terminal for air service to the island.

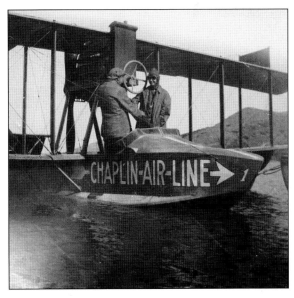

Flight service between Wilmington and Catalina Island commenced on July 12, 1919, by Chaplin Airlines. It would be the first regularly scheduled air passenger service to operate in the United States. The Curtiss MF flying boat was flown by Art Burns and carried two passengers along with bundles of *Los Angeles Examiner* newspapers. Chaplin Airlines continued their Catalina service until September 1920, when Syd Chaplin and Emory Rogers went their separate ways.

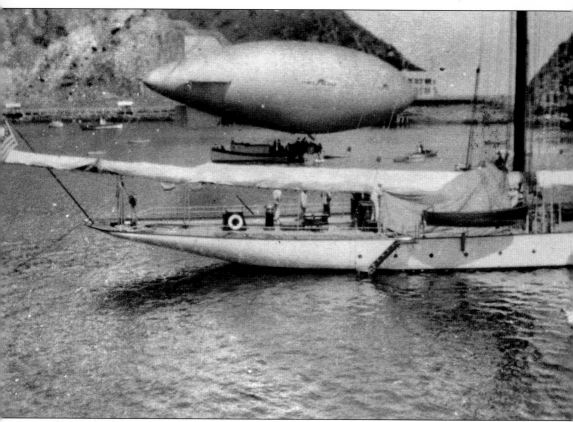

The second regularly scheduled air service between the mainland and Catalina Island was established by the Goodyear Tire and Rubber Company. The "Goodyear Pony Blimp" was built in 1919 as the smallest practical three-passenger blimp for sport, private use, and special naval use. The airship was 95 feet long with a maximum diameter of 28 feet. The airbag was inflated with nonflammable helium and the blimp powered by a single Model T Ford engine that turned a pusher propeller. On August 21, 1920, a regularly scheduled passenger service was established with the Pony Blimp between the Goodyear Balloon Field in Los Angeles and Catalina Island. The service operated six daily flights, Wednesday through Sunday, and made the 39-mile trip in one hour. Passengers were all crowded together in a small open-air basket, suspended below the airbag. The service lasted for only a short time, but it was the first dirigible airship line in America, another first for Catalina.

In 1921, pilot Hal H. Holloway inaugurated an aerial service for Catalina Island residents and visitors that he called "Fly With Me." The service did not carry passengers across the channel but rather offered scenic tours of the island aboard a Curtiss F flying boat. Holloway operated his seaplane from a ramp in Lover's Cove and thrilled passengers for two summer seasons.

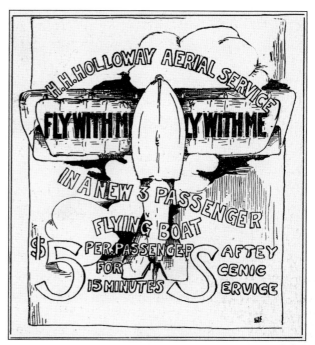

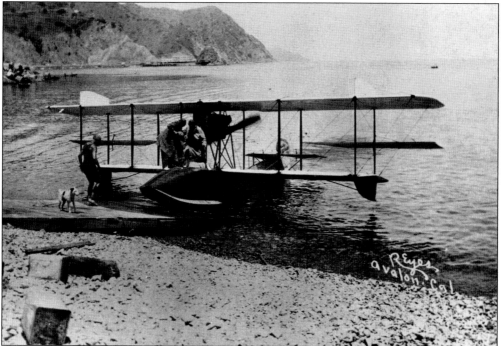

According to an article in the *Catalina Islander* on September 6, 1921, "It is in every sense true that Mr. Holloway and his flying boat have created a most favorable impression with all who have indulged in the pleasure of a ride with him. This splendid reputation has been gained by him because of the safe and sane manner in which he conducts his trips; because of the scenic beauty of the harbor and the hills over which he flies; and the very reasonable price he charges—only $5 per passenger for a 15 minute trip."

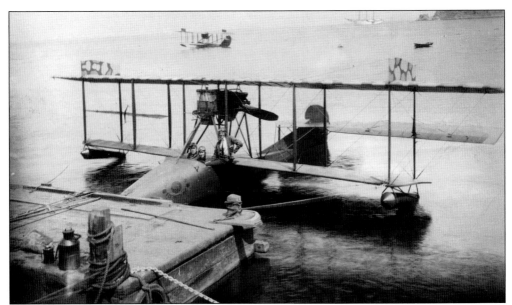

In October 1922, pilot Art C. Burns purchased Holloway's aerial service and equipment and continued to offer scenic rides for the island's residents and visitors. Burns was no stranger to flying over Catalina waters; he was a pilot for Chaplin Airlines and flew their inaugural flight in 1919. He operated his "Fly With Me" service from a float near Sugarloaf Point and offered passengers an exciting ride with a bird's-eye view of Avalon and the hills of Catalina. Burns operated his aerial sightseeing service in Avalon each summer season until 1928.

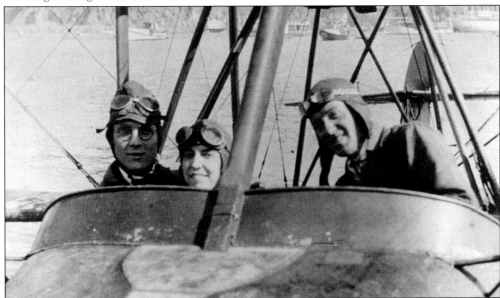

Before coming to California to manage and fly for Syd Chaplin's airline, Art Burns was a naval pilot who scouted submarines off the coast of France during World War I. He later became a flight commander at the Naval Air Station in Rockaway Beach, Long Island. During the winter months, Burns spent his time on the mainland working as a test pilot. After ending his aerial service on Catalina Island, he worked as a pilot for Transcontinental and Western Air, where he celebrated his millionth mile of flying in 1932.

Two

REGULARLY
SCHEDULED SERVICE

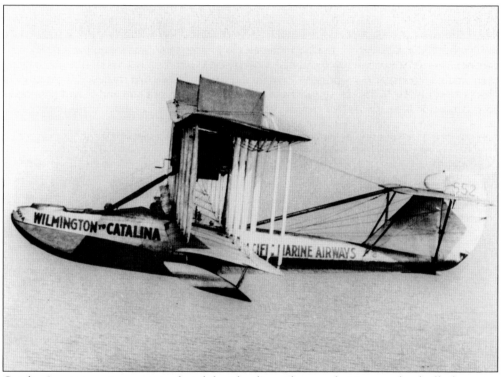

Catalina's aviation pioneers introduced the island's residents and visitors to the thrill of crossing the channel by seaplane and the convenience of reaching the island or mainland in as little as 20 minutes. The only other mode of transportation to and from the island at the time was the steamship, which took at least two hours to cross the channel. When the Syd Chaplin Aircraft Company ceased their Catalina run in 1920, the island went without regularly scheduled air service for one season, but the route was soon picked up by the newly formed Pacific Marine Airways. Businessmen and aviators Foster Curry, Wallace B. Curtis, and Ellard Bacon formed Pacific Marine Airways in 1922 and purchased two HS-2L flying boats. One plane was an open-cockpit, five-passenger plane and the other a six-passenger, deluxe-cabin plane. Pacific Marine Airways inaugurated their Wilmington-to-Catalina service in June 1922.

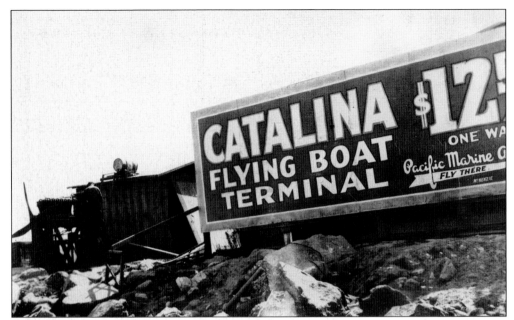

Pacific Marine Airways leased land in Los Angeles Harbor near Deadman's Island and established the Catalina Flying Boat Terminal. Trips to the island took 20 minutes at a cost of $12.50 each way or $20 round-trip. Initially three trips were offered daily, leaving the outer harbor at 10:45 a.m., 2:30 p.m., and 5:30 p.m.

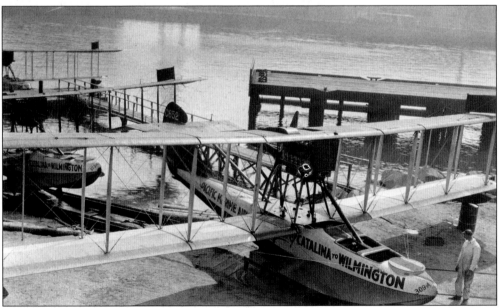

The flying ships initially flown by Pacific Marine Airways were designated Curtiss HS-2L. The Curtiss HS was a small patrol flying boat built for the U.S. Navy during World War I. The flying boat served as a warplane by patrolling against enemy submarines. The HS-2L was built in vast quantities, and at the end of the war, the surplus planes were sold on the private market. Pacific Marine Airways purchased the planes unused from the government and converted them to passenger craft.

This brochure produced by Pacific Marine Airways lured potential passengers by stating, "What word expresses to you the essence of quick transportation? FLY! You have always carried in your mind the idea that the quickest way to get from one point to another is to FLY. You have always wanted to FLY. Now you can do it. In COMFORT, with SAFETY and in the QUICKEST time, Pacific Marine Airways flying boats will carry you between Los Angeles Harbor and Catalina Island, flying ALWAYS OVER THE WATER, in the most highly perfected type of marine flying craft, and deliver you to your destination in the minimum of time. Two types of ships are used. For those who desire the sensation of a rush through the air, with unobstructed vision in every direction and the salty tang of the sea in their nostrils, the open type. While the enclosed cabin de luxe flying limousine offers a vehicle into which any lady can step, wearing her party gown, make the trip in the greatest of comfort and alight without a hair of her coiffure disarranged."

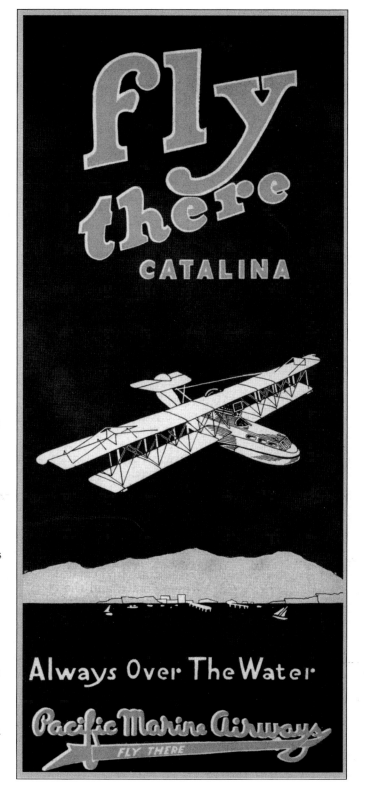

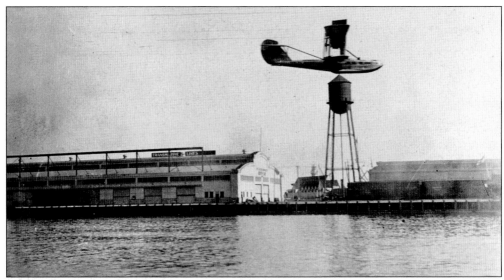

A trip to Catalina Island via Pacific Marine Airways commenced as passengers boarded one of their flying boats in Los Angeles Harbor. In an article in the *Catalina Islander* on July 12, 1922, Judge Ernest Windle recalled one such trip:. "At Deadman's Island, the plane quickly rose from the water and climbed to an altitude of 500 feet. Our huge bird went over the breakwater, and below us was the lighthouse. The steamer Cabrillo was just rounding that picturesque structure. One does not fully realize the length of the San Pedro breakwater until they have passed over it in a seaplane. Flying low, perhaps 200 feet above the surface, towards the island, we passed over commercial fishing boats with thousands of seagulls hovering over them and occasionally the metallic colors of fish shone brilliantly in the sun penetrated sea."

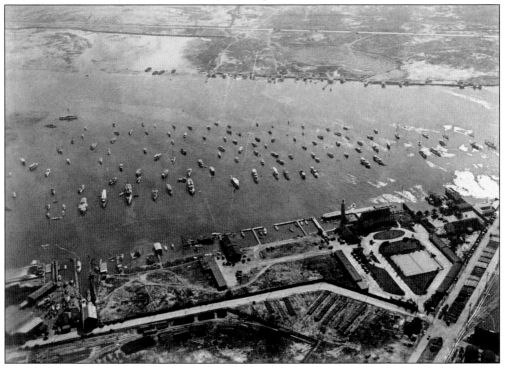

Judge Ernest Windle continued to recall his flight that day aboard Pacific Marine Airways flying limousine by stating, "In the distance lay Catalina, a dark blue island rising out of a mist of fleecy clouds against a golden sky. As we neared Avalon Bay we flew over the S.S. Avalon leaving the dock on her scheduled sail to the mainland. Passengers on the upper decks waved to us. We circled over the residence of William Wrigley Jr. on Mt. Ada, inland over the golf course, and back over Avalon Bay to land gently in the smooth waters. Across the channel I had flown, and there had been no more sensation to it than if I had just stepped off a street car or out of an automobile. The seaplane was more than comfortable."

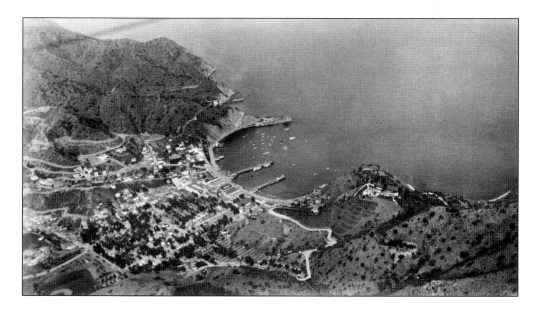

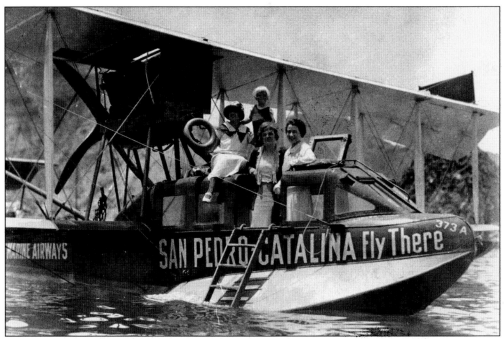

Once the flying boats arrived in Avalon Bay, they would taxi to the Pacific Marine Airway anchorage at Lover's Cove and passengers would be shuttled by boat to shore. In later years, the airline negotiated with the Santa Catalina Island Company to install a landing float near Sugarloaf Point, which proved more convenient for the pilots and passengers.

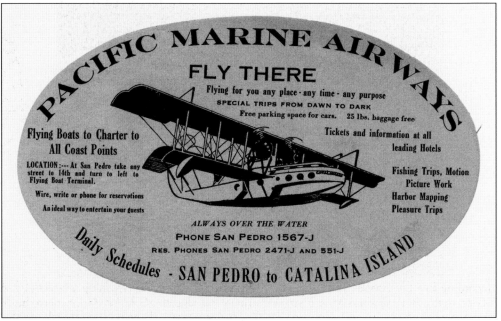

By 1927, Pacific Marine Airways was the largest flying boat service in the world and had grown to be one of the big businesses of the Los Angeles Harbor District. They carried thousands of passengers to and from Catalina Island, provided charter flights to all coastal points, dabbled in motion picture work and harbor mapping, and offered special fishing trips for adventurous sportsmen.

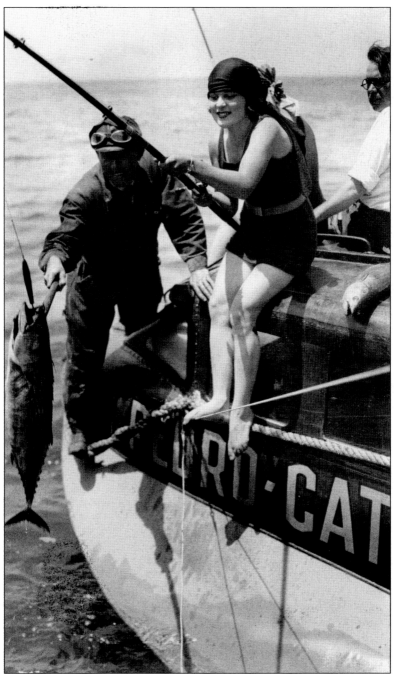

According to a *Los Angeles Times* article on July 13, 1922, "Rivaling flyfishing as an object of interest to the sporting world is the 'Flying Fisherman' introduced to Southern California recently when a party of thrill-seekers hopped in a Pacific Marine Airways flying boat, spotted their game from an altitude of 500 feet, landed and caught 200 pounds of assorted varieties of fish. The ease with which this feat was accomplished demonstrated the versatility of the seaplane as a sporting craft, and in the opinion of those who made the trip, it is only a question of time before the motor boats will be thrown into the discard as far as deep sea fishing is concerned."

Pacific Marine Airways served Catalina well with consistent, safe, regularly scheduled service from 1922 until 1928, when the company was purchased by Western Air Express, Inc. Ellard A. Bacon, one of the founders of Pacific Marine Airways, reported that during their six years of operation, the airline carried over 15,000 passengers without accident or injury. At the time, Pacific Marine Airways was the oldest commercial airline in the United States and held the record for the largest passenger carrying service until 1938.

Western Air Express was founded by Harris M. Hanshue in July 1925, just after the U.S. Postal Service began to offer air mail contracts to private airlines. Hanshue applied for and was awarded the contract air mail route from Los Angeles to Salt Lake City, Utah. Shortly after commencing this air mail route, the airline entered into the passenger transport business. Hanshue quickly expanded Western Air Express by acquiring other small airline operations, including Pacific Marine Airways in 1928.

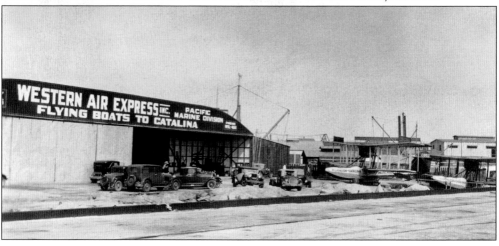

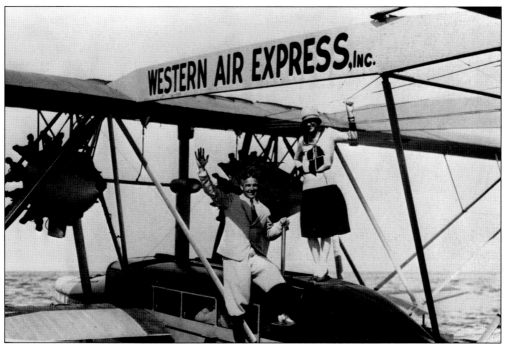

Western Air Express absorbed Pacific Marine Airways in June 1928. Harris Hanshue retained the services of Ellard A. Bacon and created the Pacific Marine Division of Western Air Express Corporation. The Pacific Marine Division continued to operate three Curtiss HS-2L flying boats between Los Angeles Harbor and Catalina Island and soon expanded their service by adding a Sikorsky S-38 to the fleet.

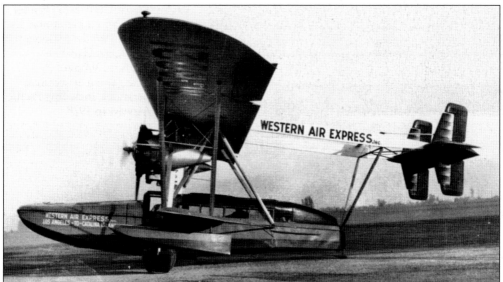

The Sikorsky S-38 was added to the Catalina run in July 1928 and operated from a Western Air Express terminal at Vail Field in Los Angeles. The plane was equipped with dual service landing gear, having both pontoons and wheels, thus making it possible to stop on the landing field or in the bay. The addition of the Sikorsky S-38 to the Western Air Express fleet allowed the airline to claim they were the only airline in the world operating on both land and water.

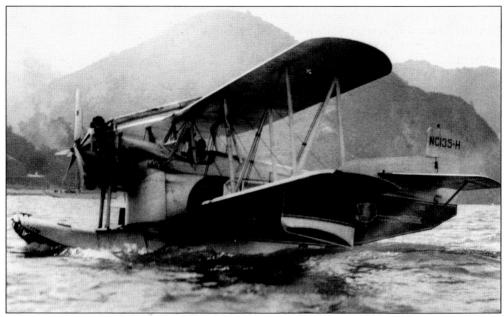

Western Air Express later added two Loening C-2H Amphibians to their fleet in 1929. The planes were purchased from the Loening Aeronautical Engineering Corporation in New York and flown to Los Angeles. The Loening carried two pilots and eight passengers. It was equipped with a 525-horsepower Hornet engine and could fly up to 135 miles per hour. The Loening was equipped with dual landing gear and flew between Vail Field and Avalon Bay in 30 minutes.

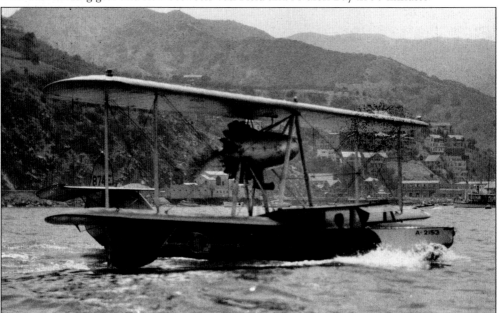

In July 1929, Western Air Express introduced a new sightseeing service in Avalon Bay offering short scenic hops aboard a Boeing 204 flying boat. The flying boat was the last model built by the Boeing Airplane Company specifically for private use by civilians. The four-passenger plane was kept on the island during the summer season and offered joyrides for adventurous residents and visitors.

The seaplane pilots of Catalina were viewed as larger than life. Many were aviation pioneers, having taught themselves to fly and serving in various branches of the military. They were also known to be heroes, saving lives by flying sick or injured passengers to the mainland and by spotting swimmers and boaters in distress. In one such case, Western Air Express pilot Franklin Young rescued a young woman from an overturned canoe. From 200 feet, Young spotted the woman struggling to reach shore and quickly set his plane down and taxied to her rescue.

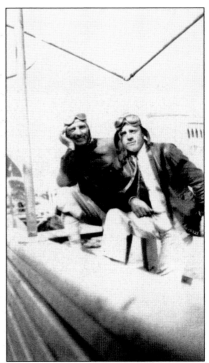

Catalina's Casino Building was completed in May 1929 and quickly became the island's greatest attraction. A boardwalk to the building covered in wooden arches was also constructed, and Western Air Express decided to build a stand at the edge of that walkway. The Western Air Express stand had an office and waiting room adjacent to a ramp attached to a float. Passengers boarded the amphibians from the float for a joyride or a return trip to the mainland.

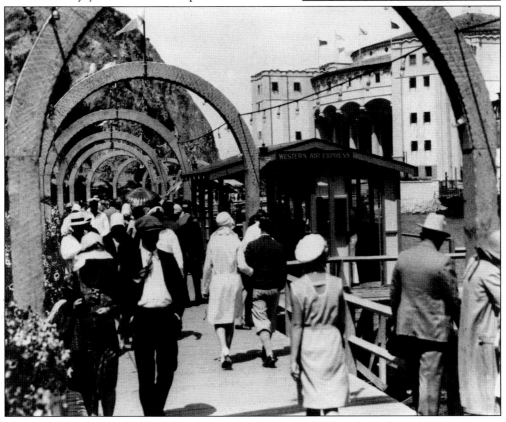

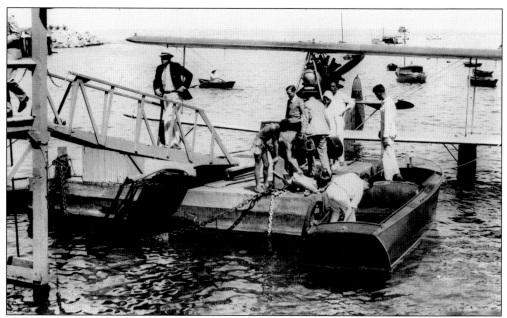

The Western Air Express service was quite popular. According to an article in the *Catalina Islander* on August 4, 1929, "During the past 31 days, 2,448 persons were transported between Catalina Island and Los Angeles. This is an approximate average of 50 persons a day, and includes the use of amphibians from the local airport and seaplanes operating from Wilmington. All ships running to Avalon have been loaded to capacity."

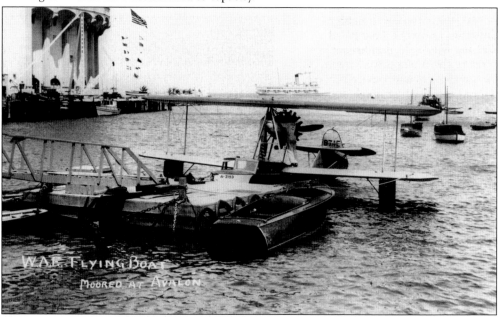

Western Air Express provided passengers with a quality and convenient service, operating a variety of aircraft from three points on the mainland (Vail Field, Wilmington, and Alhambra Airport) to Catalina Island. They continued this service until 1931, when their contract with the Santa Catalina Island Company expired and was not renewed. Western Air Express continued their mainland operations and later merged with Transcontinental Air Transport to form TWA.

Three

WILMINGTON-CATALINA AIRLINES

In 1931, the Santa Catalina Island Company, under the direction of William Wrigley Jr., decided not to renew the Western Air Express contract for seaplane service between Wilmington and Catalina Island because they wished to venture into the aviation business themselves. Wrigley's son Philip had long been interested in aviation and saw a great opportunity for the Santa Catalina Island Company to take over the Wilmington-to-Catalina route. Wrigley established Wilmington-Catalina Airline, Ltd., in May 1931 and applied for a certificate to operate a daily seaplane service between Los Angeles Harbor and Avalon. Philip K. Wrigley was named president of the new airline with David P. Fleming serving as secretary, Malcolm Renton as treasurer, and E. MacFarland Moore serving as the aviation expert manager. Hamilton Beach (located just north of Descanso Bay) was chosen as the site for a new amphibian airport, and construction quickly began.

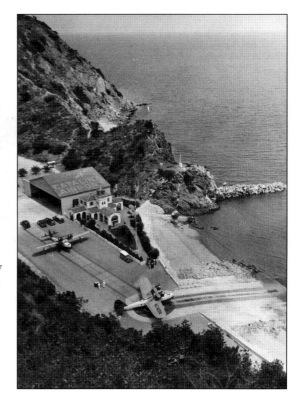

Philip K. Wrigley, the only son of William Wrigley Jr., was highly involved in all of his father's business ventures, including his purchase and development of Catalina Island. He had accompanied his parents on their first visit to the island in 1919, understood his father's vision for the island, and was committed to helping bring that vision to reality. Philip became intimately involved in the island's development and brought many of his own interests and ideas to the table. Previously, Philip had served in the U.S. Navy as the head of training for aviation mechanics at the Great Lakes Naval Training Station. It was during this time that Philip's love of aviation took flight. He later founded one of the earliest scheduled passenger airline services, American Airways, in 1926. This company later merged with National Air Transport and was eventually absorbed by United Airlines in 1931. Philip K. Wrigley brought his passion for aviation to the island when he helped develop Wilmington-Catalina Airlines, Ltd.

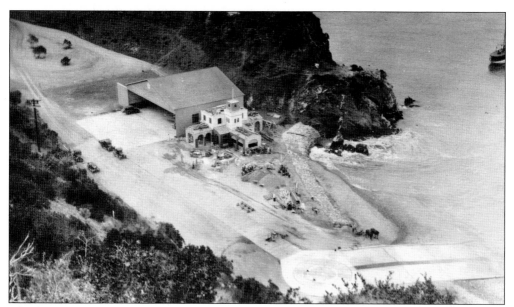

The first important decision made by the officers of the newly formed Wilmington-Catalina Airline was to determine a suitable location for an air terminal on Catalina Island. Hamilton Beach was selected because it was within a convenient distance from the city of Avalon, it was isolated just enough by the surrounding hills to give it privacy, and this particular cove was the most protected and sheltered of any near Avalon, which made it suitable for the construction of a concrete ramp. (Courtesy Santa Catalina Island Company.)

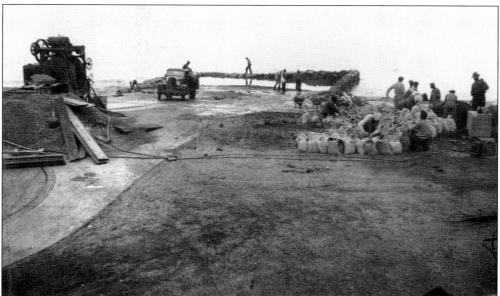

The construction of the 40-by-120-foot concrete ramp was quite a feat. Much of the work had to be done during low tide so the ramp could extend as far as possible into the water. A concrete retaining wall was initially laid on both sides of the ramp area, and then a layer of concrete was poured on top. A 4-foot-wide strip was left open in the center of the ramp, and wooden planks were placed to prevent the tail skids of the airplanes from wearing off as they went down the concrete ramp.

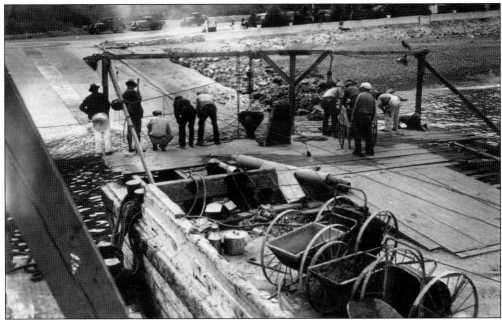

At the top of the ramp was the most distinctive feature of the new Catalina Airport—the turntable. The turntable system was an entirely new innovation in aeronautics and was the brainchild of Philip K. Wrigley. Having been inspired by old-fashioned railroad turntables, Wrigley devised an easy way for the seaplanes to taxi up the runway and then quickly be turned around for takeoff.

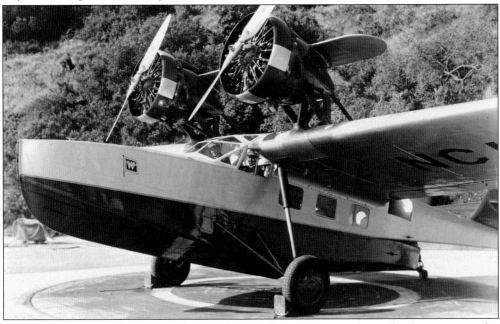

The turntable was 27 feet wide with a wooden top. Its construction began by digging a circular pit about 4 feet deep, and a concrete footing was poured around the circumference of the pit. Upon this was laid a circular track designed to support the turntable. Eight car wheels supporting an iron frame covered with wooden planks formed the movable part of the turntable. (Courtesy Santa Catalina Island Company.)

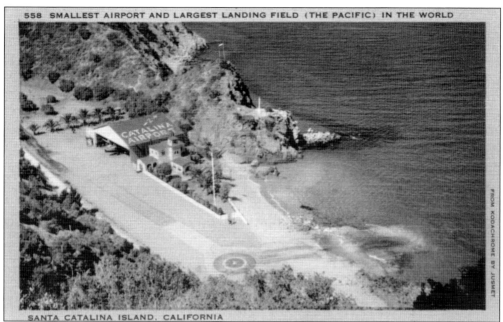

SANTA CATALINA ISLAND, CALIFORNIA

On August 1, 1931, the Catalina Airport hosted a gala celebration to commemorate the official opening of the airport and the inaugural flight of Wilmington-Catalina Airline. Visitors marveled at the innovative runway design and the beautiful administration building, which included waiting rooms, a lounge, reading rooms, a refreshment counter, ticket booth, and adjacent garden patio. The airport quickly became known as the "smallest airport with the largest landing field (the Pacific) in the world."

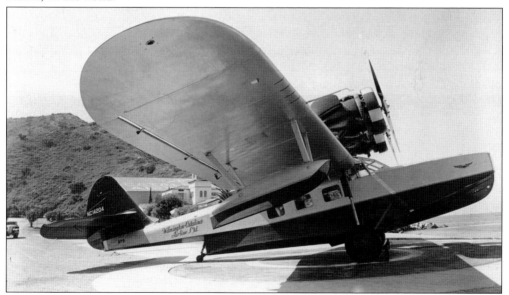

The signature aircraft flown by Wilmington-Catalina Airline was the Douglas Dolphin. The Dolphin was manufactured by the Douglas Aircraft Company and was designed by Donald Douglas himself. The plane was originally built in 1929 and was known as "Sinbad." It was a twin-engine, cantilever-winged, monoplane amphibian with a yacht-like Duraluminum hull. The amphibian was later renamed Dolphin and was manufactured and sold to the U.S. military.

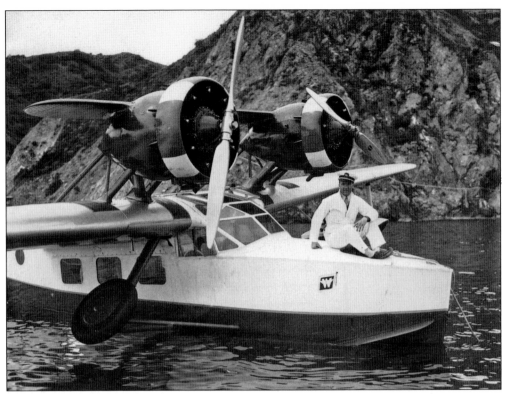

Philip K. Wrigley was friends with Donald Douglas, and upon the creation of his new airline, Wrigley turned to Douglas for advice and airplanes. The 10-passenger Dolphin proved to be the perfect machine for Wrigley's needs. The Dolphin had a 60-foot wingspan and was 45 feet in length and 15 feet high with a cruising speed of 135 miles per hour. The planes flew a distance of 27 miles from Wilmington to Catalina in 15 minutes at an average altitude between 500 and 1,000 feet.

The Dolphins were equipped with two Pratt-Whitney Wasp motors that each developed 450 horsepower at 2,100 revolutions per minute. The propellers were made of standard steel and had a 9-foot diameter. The planes were equipped with wingtip floats near the extremity of each wing, which served to keep the plane balanced while on the water.

Wilmington-Catalina Airline also flew a Loening C-2H Amphibian. In fact, the Loening Amphibian was the first plane purchased by the company in June 1931. The Wilmington-Catalina amphibian was purchased in Chicago and flown cross-country by pilot Ira Smalls. The plane made the trip from Chicago to Avalon in 27 hours and 45 minutes of actual flying time.

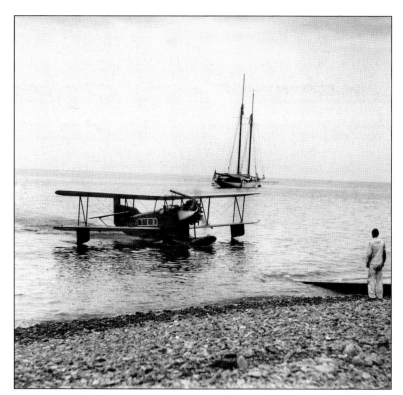

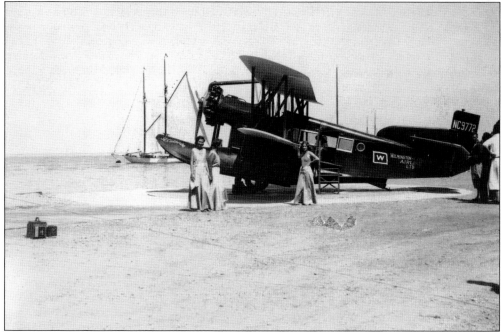

The Loening NC9772 was christened "St. Catherine" and made its inaugural flight for Wilmington-Catalina Airline on June 10, 1931, with several Santa Catalina Island Company officials aboard. The amphibian carried six passengers across the channel in 18 minutes at a cruising speed of 110 miles per hour. (Courtesy Santa Catalina Island Company.)

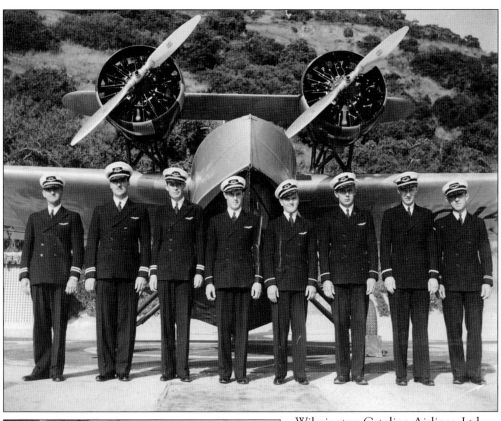

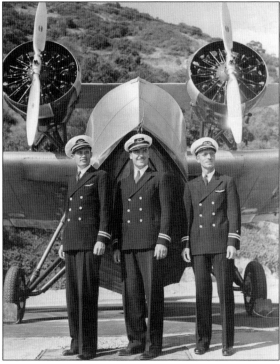

Wilmington-Catalina Airlines, Ltd., employed several pilots, copilots, mechanics, traffic men, and ticket agents, who all played an important role in the success of the airline. Several of these employees are pictured here from left to right at the Catalina Airport in 1936: Ray Crawford, Bob Simmons, Harry Downs, George Ryan, William Jamison, Henry Rideort, Jack Emmerich, and Jack Hill.

The pilots of Wilmington-Catalina Airlines were all highly skilled and experienced, having thousands of hours of flying time among them. In September 1942, it was reported that the airline had carried more than 300,000 passengers in 44,000 flights without incident. Pictured here are, from left to right, pilots Harry Downs and Bob Simmons along with chief pilot Walter Seiler.

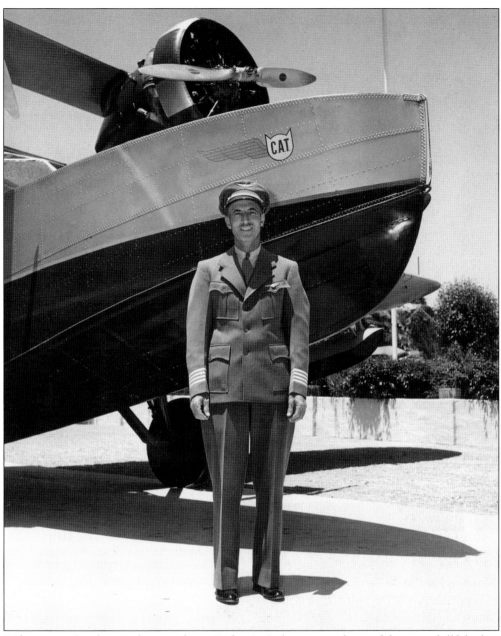

Wilmington-Catalina Airline employee Walter L. Seiler was rated one of the most skillful pilots on the Pacific Coast. Before coming to Catalina Island, Seiler had retired from the U.S. Navy after 30 years of service. He attended Royal Naval Air Service School in England in 1917 and served with English and French units during World War I, for which he received the Distinguished Service Cross. Seiler's exemplary record and experience prompted Wilmington-Catalina Airlines to hire him as their chief pilot in 1931. He quickly became one of their most valued employees and was later named superintendent and vice president of the airline. By 1942, Seiler was credited with flying more than 9,650 trips for Wilmington-Catalina Airline.

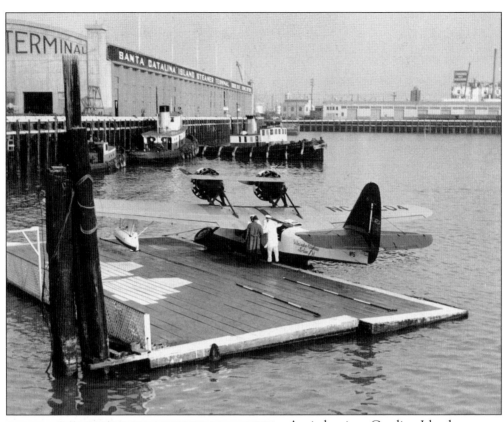

A trip by air to Catalina Island via Wilmington-Catalina Airline commenced in Los Angeles Harbor. The airline leased space adjacent to the Catalina Terminal in Wilmington from where the steamships operated. The air depot was a three-minute walk from the streetcar service that carried passengers to the harbor from many points throughout the Los Angeles area.

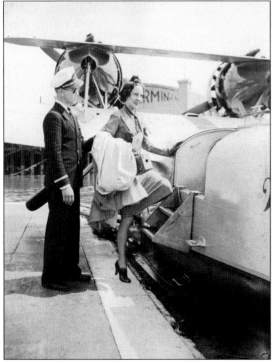

Passengers stepped aboard one of the Wilmington-Catalina Airline amphibians from a large float to begin their adventure. The seaplane would taxi around the harbor to thoroughly warm the engines, and the pilot would then take cues from flagmen stationed along the channel reporting wind direction and ship traffic. When all was clear, the pilot would increase the motor speed and easily rise into the air.

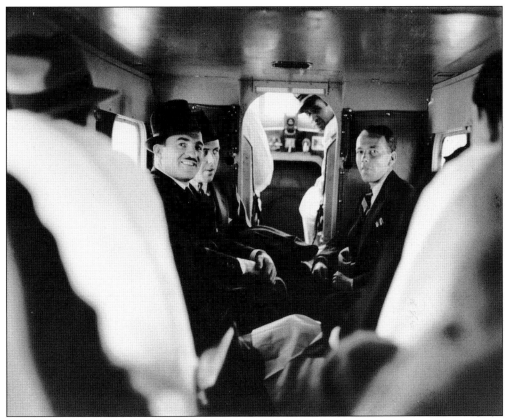

The interior of the Douglas Dolphin was quite comfortable and could accommodate up to 10 passengers. According to a July 1, 1931, article in the *Catalina Islander*, "The plane is beautifully upholstered and is the last word in comfort and luxury for the 'air-minded' passengers who crave speed in their cross channel transportation." (Courtesy Santa Catalina Island Company.)

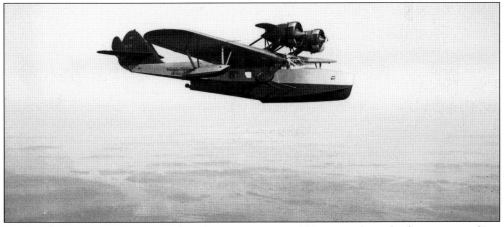

As the plane rose to its cruising altitude, passengers would be treated to a bird's-eye view of Los Angeles Harbor and then the vast Pacific Ocean would open before their eyes. The plane would cruise at a speed of 135 miles per hour, reaching Catalina Island in 15 minutes. Along the way, passengers would enjoy spotting schools of fish, commercial fishing boats, and pleasure boats plotting their way across the channel.

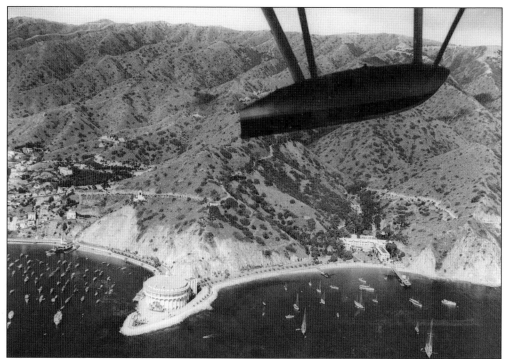

Soon, in the distance, the hills of Catalina would rise from the mighty Pacific and passengers would be treated to views of the beautiful hills and canyons of the island below. According to a *Catalina Islander* article on December 9, 1931, "As the pilot turned the plane in preparation for landing, passengers would get a panoramic view of Avalon Bay and its varied collection of water craft, ranging from row boats to palatial ocean-going yachts, and perhaps one of the cross channel passenger steamers tied to the dock." After the plane landed in the water, the retractable wheels were let down and the plane would draw up the ramp to the turntable, where the plane would be swung around and the passengers would disembark.

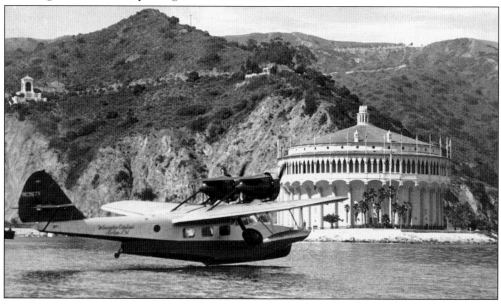

The December 9, 1931, article continues to describe the journey by air to Catalina aboard Wilmington-Catalina Airlines by stating, "As the passengers leave the plane, they see to the right one of the most modern airports in the world. The administration building built in Spanish style with trimmings of Catalina tile and a huge hangar in the background. Large comfortable buses await the arrival of the planes and the passengers and baggage are transported to the town of Avalon, a distance of one mile. After passing the Hotel St. Catherine, the yacht and Tuna Clubs, passengers arrive at Avalon, well known for its scenic setting."

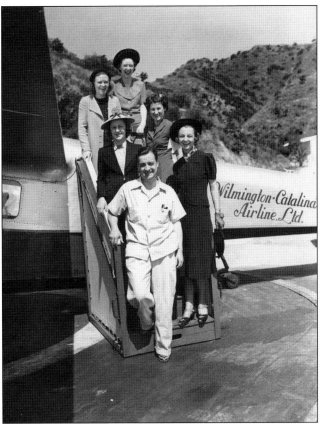

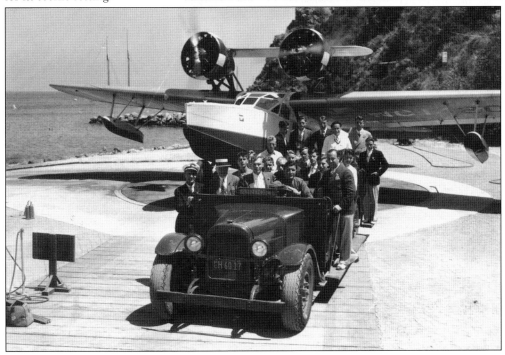

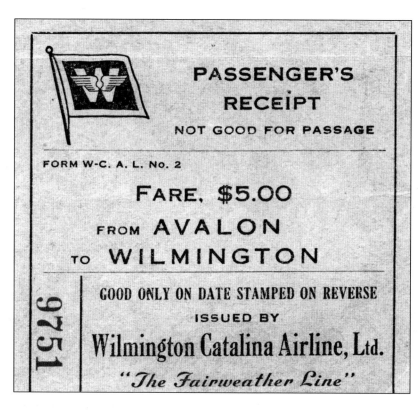

PASSENGER'S RECEIPT

NOT GOOD FOR PASSAGE

FORM W-C. A. L. No. 2

FARE, $5.00

FROM AVALON

TO WILMINGTON

GOOD ONLY ON DATE STAMPED ON REVERSE

ISSUED BY

Wilmington Catalina Airline, Ltd.

"The Fairweather Line"

9751

A trip by air aboard one of Wilmington-Catalina Airline's Douglas Dolphins was $5 each way. The airline also offered a special rate for employees and island residents. This souvenir passenger's receipt advertises the airline as "The Fairweather Line," and it certainly was. (Courtesy Allan and Laurie Carter.)

A common souvenir during this age of travel was the luggage sticker. Luggage stickers were produced by many airlines, and a variety of stickers were created especially for Catalina by the island's steamship line. This wonderful luggage sticker served as a great souvenir to remind passengers of their unique trip by air to Catalina Island.

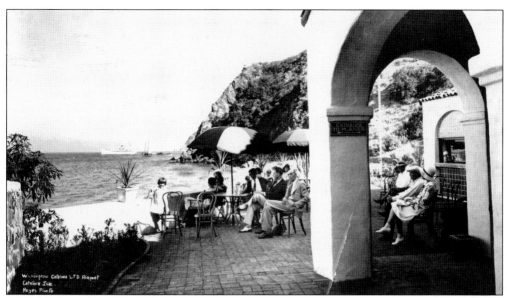

The return trip via Wilmington-Catalina Airlines allowed passengers leisure time at the Catalina Airport to enjoy refreshments on the beautiful garden patio. The garden was known as the "Orilla Jardin." According to a *Catalina Islander* article on August 5, 1931, "Truly, there is no more delightful spot to enjoy an afternoon, or a whole day, for that matter, than in the Orilla Jardin, with its cool cloister and vistas out to sea, its patios and palisades. Suggestive of a fashionable European watering resort, with its huge, bright colored umbrellas spread over lovely tile tables, alluring settees placed along the flowers and along the sea wall, the Catalina Airport combines the functions of the up-to-date air base and the social environment of an Aviation Country Club." (Both courtesy Santa Catalina Island Company.)

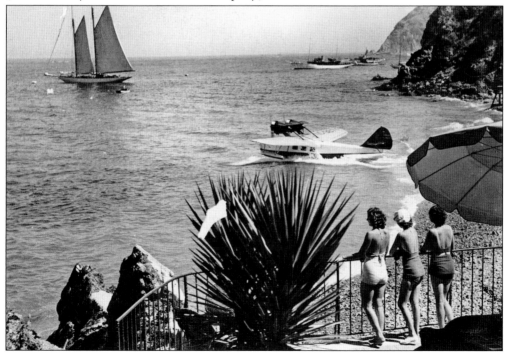

Wilmington-Catalina Airline, Ltd., operated regularly scheduled daily seaplane service to and from Catalina Island for over 10 years. The airline was quite successful, and residents and visitors appreciated the option of a safe and fast link to the mainland as much as they enjoyed flying in the seaplanes. In January 1941, the airline's board of directors was looking to expand the airline's

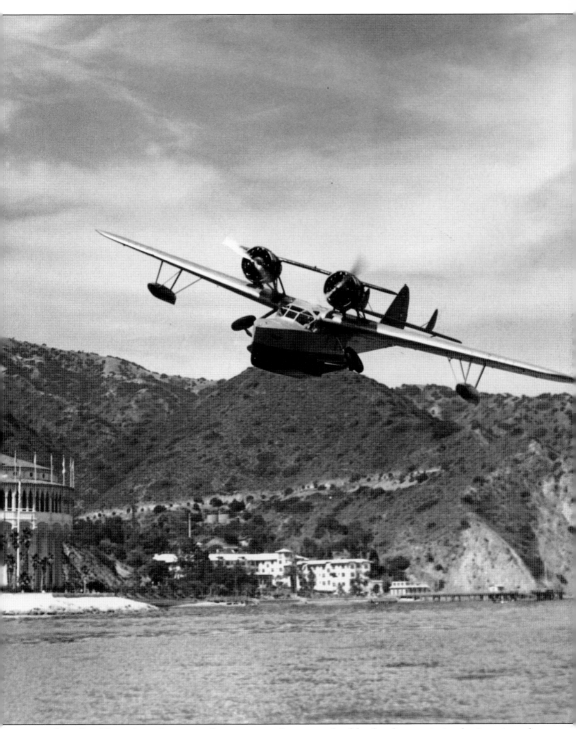

reach to land-based airplanes as plans were underway to build a landing strip in the interior of the island. The group officially renamed the airline Catalina Air Transport. It seemed a bright future was ahead until the onset of World War II changed everything. (Courtesy Santa Catalina Island Company.)

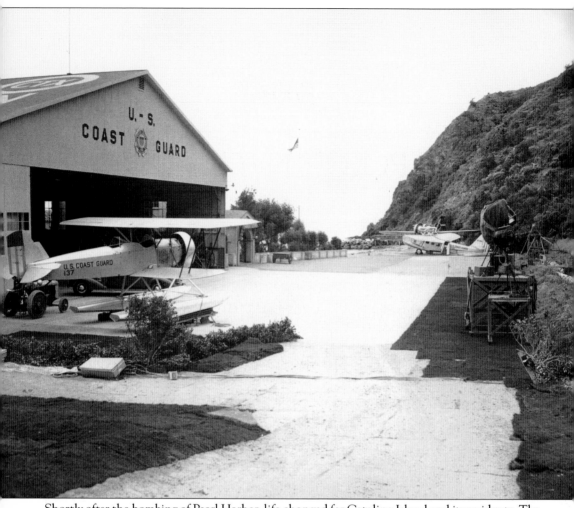

Shortly after the bombing of Pearl Harbor, life changed for Catalina Island and its residents. The initial effects were in transportation. Within two weeks, the U.S. Coast Guard ordered regularly scheduled steamship passenger service ceased. Catalina Island was declared a federal military zone, and the San Pedro Channel was designated a controlled area for vessels. Air passenger service was closely monitored by the coast guard for awhile until it was completely shut down in September 1942. With the cessation of water and air passenger service to the island, resort activities were abandoned. The Santa Catalina Island Company appealed to the military to utilize the island toward the war effort, and several branches of the military answered the call. The U.S. Army Signal Corps set up a sophisticated radar station on the island, while the U.S. Maritime Service, the Office of Strategic Services, and the U.S. Coast Guard all set up training bases. Catalina Air Transport's amphibian planes were requisitioned by the U.S. Army, and the Coast Guard took over operations of the Catalina Airport. Unfortunately, the beautiful Catalina Airport at Hamilton Beach never reopened after the war, when all air operations moved to the new Airport-in-the-Sky. (Courtesy Santa Catalina Island Company.)

Four

AIRPORT-IN-THE-SKY

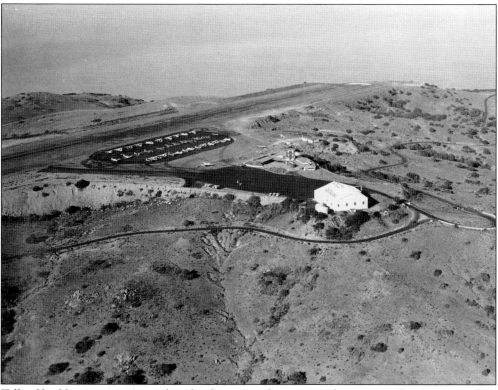

Talk of building an airport in the island's interior began as early as 1930. The Santa Catalina Island Company made plans to build an airport to accommodate land-based planes operated by Western Air Express, which already operated amphibians in Avalon Bay. This plan never came to fruition, but talks about an airport for land-based planes on Catalina Island continued throughout the 1930s. By 1938, momentum for the project picked up again and the Santa Catalina Island Company announced plans. According to an article in the *Los Angeles Times* on May 20, 1938, "Formulation of plans to hew an airport out of a mountain peak on Santa Catalina Island and the signing of a lease permitting use of Long Beach Municipal Airport brought modern, land-plane communication between the holiday island and the mainland nearer. It was announced that by the spring 1939, the unusual landing field on one of Catalina's tallest elevations will be completed." Actual construction did not begin until 1940, but the Santa Catalina Island Company did deliver on their promise to build an airport in the sky.

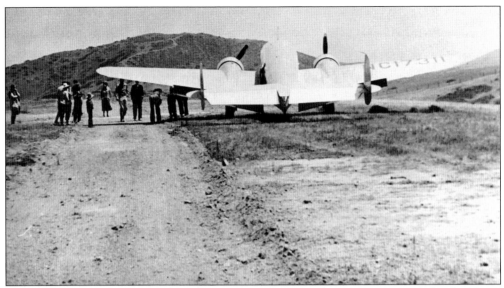

The first land-based plane touched down on Catalina Island in 1938 on a road that had been specially graded by the Hugh Smith Construction Company. The road was near Philip K. Wrigley's Arabian horse ranch, El Rancho Escondido. Wrigley had been in search of the best place to build an airport for commercial aviation and also wished to land his own DC-3 on the island, ideally near his ranch. This initial landing was a test of the location. The twin-engine Lockheed Lodestar was operated by William Patterson of United Airlines and Justin Dart, founder of the Owl-Rexall Drug Company.

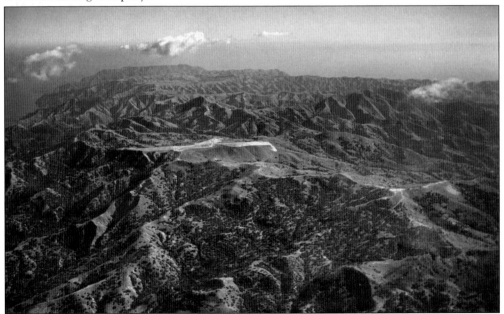

The Santa Catalina Island Company invested much time and money to determine the best location for Catalina's new airport. According to a *Catalina Islander* article on May 22, 1947, "After looking the whole place over, the site at what was known as Buffalo Springs was selected. Then began a period of weather observations to make sure that the site was practical and dependable for landings and take-offs."

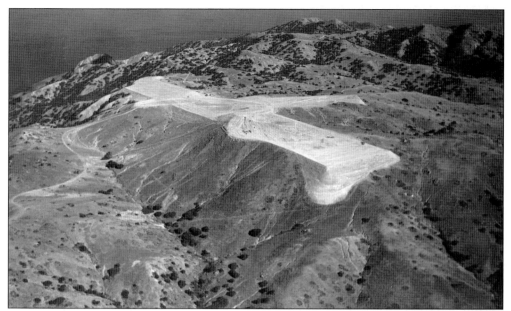

In August 1940, the Santa Catalina Island Company, through its affiliate, Catalina Air Transport, contracted with three construction companies to begin construction at Buffalo Springs, 10 miles northwest of the city of Avalon. According to a data sheet published by the Santa Catalina Island Company, "Though many airports in the United States have been built by filling in lands at low altitudes, Catalina's unique airport was accomplished by shearing off mountain tops."

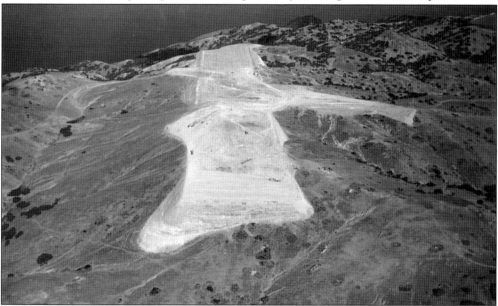

The Santa Catalina Island Company's data sheet continues to explain, "Three construction companies with a mechanized army of nine 30-ton carry-alls, eight large Caterpillar tractors, four bulldozers and a fleet of trucks were used. They literally 'moved mountains.' Adjacent canyons, yawning chasms nine stories deep, had to be filled, thus equalizing what had been a discrepancy of 15 stories in the canyon and mountain levels. Over a million cubic yards of dirt had to be removed—200,000 truckloads."

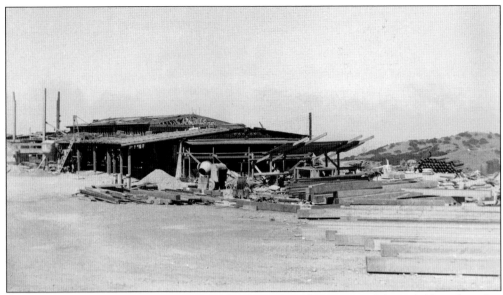

Construction of the runway ceased after the breakout of World War II, and the airfield was leased to the U.S. Army. The army placed numerous obstacles on the runway to deter any possible landings by enemy aircraft for the duration of the war. The field was returned to the Santa Catalina Island Company in January 1946, and plans to complete the runway and airport were once again set in motion. The surface of the runway was paved with asphalt, and by July, construction of the airport administration building began. (Courtesy Santa Catalina Island Company.)

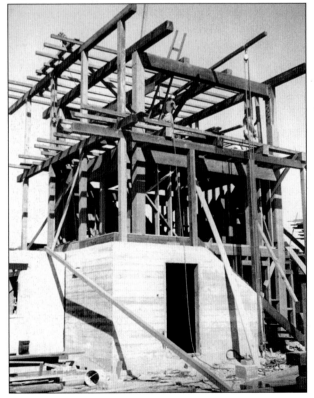

During the airport's initial construction, a temporary control tower was built to monitor the movement of aircraft on and around the airport. The wooden structure looked more like an oil derrick than an aircraft control tower. The old tower was later removed to make way for a new, sophisticated tower that was incorporated into the design of the airport's administration building. (Courtesy Santa Catalina Island Company.)

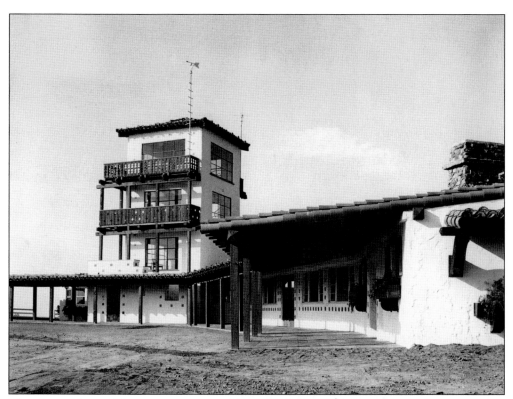

The airport's beautiful administration building was completed by summer 1947 and included a large lounge for passengers, a ticket counter, air traffic control tower, and administrative offices. According to an article in the *Catalina Islander* on August 14, 1947, "This charming terminal building contributes a character, charm and convenience which makes Catalina's airport one of the most beautiful and unusual airports in the world today."

Rising high above the airport's administration building, the air traffic control tower was designed and constructed with windows on all four sides to afford the air traffic controllers a 360-degree view of the sky, runway, and airport facility. The tower also provides amazing views of the island and the mainland on a clear day.

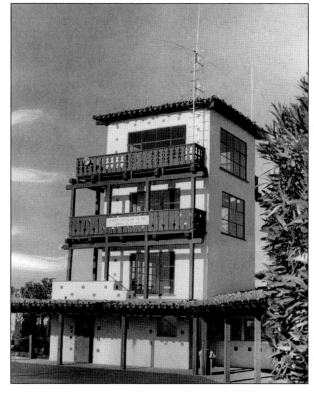

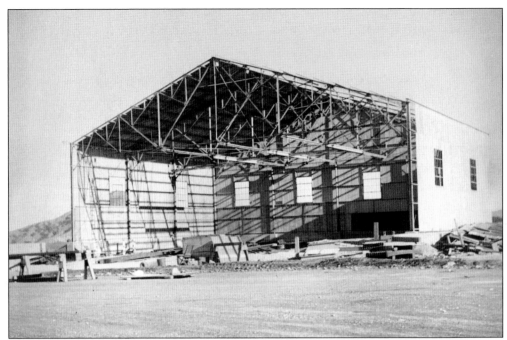

The airplane hangar at the Airport-in-the-Sky actually was originally constructed for Wilmington-Catalina Airline, Ltd., at their Catalina Airport at Hamilton Beach. When it was decided to abandon the airport operations at Hamilton Beach, the hangar was carefully taken apart and moved to the Airport-in-the-Sky. The hangar can accommodate several large planes and housed Philip K. Wrigley's DC-3 airplane during his visits to the island. The hangar stands opposite the administration building at an elevation of 1,602 feet. (Courtesy Santa Catalina Island Company.)

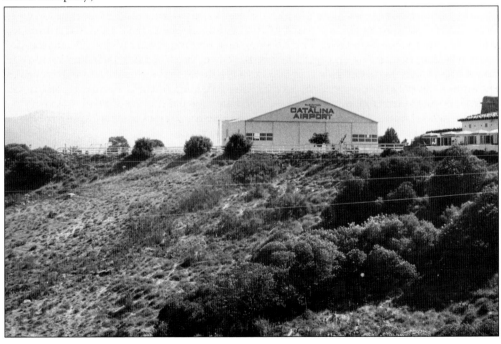

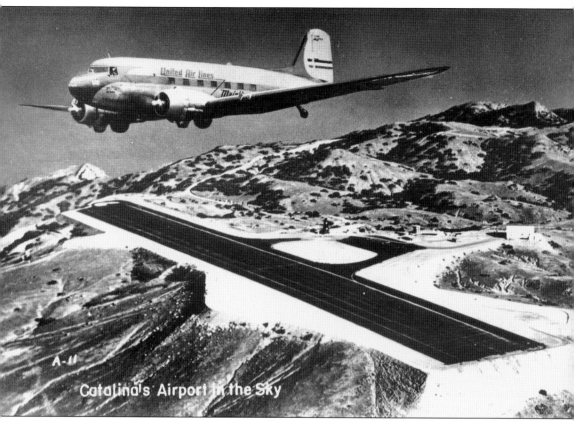

Catalina's Airport in the Sky

With the runway, administration building, and hangar complete, the Airport-in-the-Sky officially opened on June 27, 1946, with a new cross-channel air service operated by United Airlines. United Airlines traces its history back to 1926 when Walter Varney commenced an air mail service in Boise, Idaho. This new service was the first "true" airline service in the United States operating on fixed routes and fixed schedules. The following year, airplane pioneer William Boeing founded his own airline, Boeing Air Transport, and began buying other airlines, including Varney's air mail service. Boeing's holdings grew to include several airlines, airplane manufacturing companies, and airports. In 1929, the company changed its name to United Aircraft–Transport Corporation. In 1934, Boeing's corporation was broken up into three companies, one of which was an airline group known as United Airlines. United Airlines was an easy fit for Catalina Island since Philip K. Wrigley had been involved with the airline for many years.

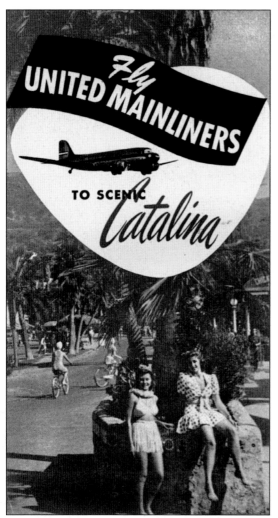

United Airlines' new flight route operated between Catalina's Airport-in-the-Sky and three mainland terminals. According to a July 18, 1946, article in the *Catalina Islander*, "The 26 minute air journey is a thrilling experience enjoyed in the modern comfort of United's deluxe Mainliners—the same twin-engined planes flying their transcontinental route."

The DC-3 Mainliner 180s flown by United Airlines on their Catalina route were 64 feet, 5 inches in length and 16 feet, 4 inches high with a wingspan of 95 feet. They cruised at a speed of 170 miles per hour and were equipped with two nine-cylinder radial cooled engines.

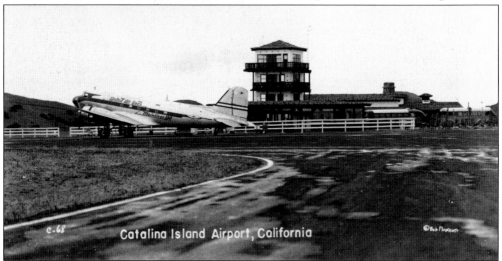

Catalina Island Airport, California

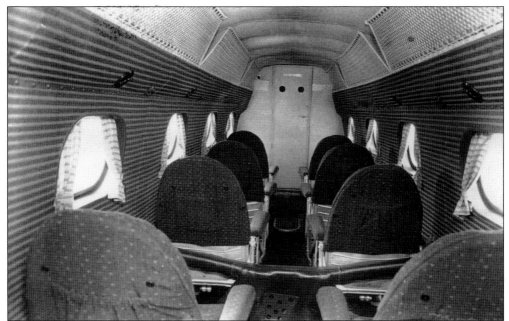

The deluxe Mainliners were quite comfortable, holding up to 21 passengers. According to a United Airlines brochure, "Fly swiftly to friendly Catalina Island in United's Mainliner 180s. Frequent daily flights each way make it conveniently easy for you to visit this famous year-round paradise from any point in the Los Angeles area—for a day, a weekend or a care-erasing vacation. Board the Catalina Mainliner at any one of United's local terminals . . . Los Angeles Airport, Long Beach Municipal Airport or Lockheed Air Terminal in Burbank. In just a few scenic minutes your plane is approaching Catalina's unique island-top airport, which overlooks the blue Pacific and the distant California coastline."

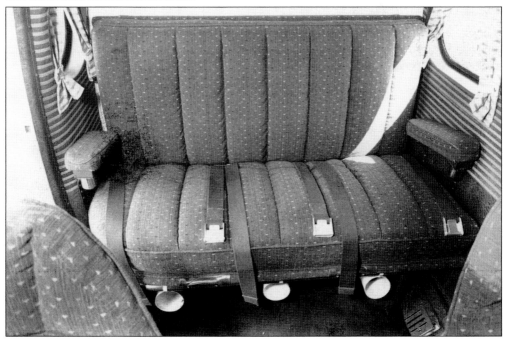

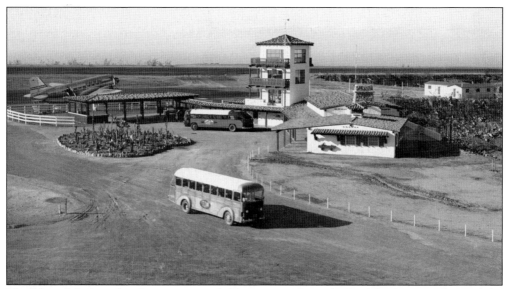

The United Airlines brochure continued, "As you step from the big Mainliner, in front of the terminal, you'll find yourself high on a great, sunny plateau, with rolling, oak-covered mountains on every side. The limousine that waits to take you from the airport to Avalon follows a spectacular scenic highway that you'll long remember as one of the highlights of your visit. You can enjoy service in the 'Mainliner manner' each way . . . or, if you prefer, you can travel one way by United Mainliner, and one way by Catalina steamer between Avalon and Wilmington." (Both courtesy Santa Catalina Island Company.)

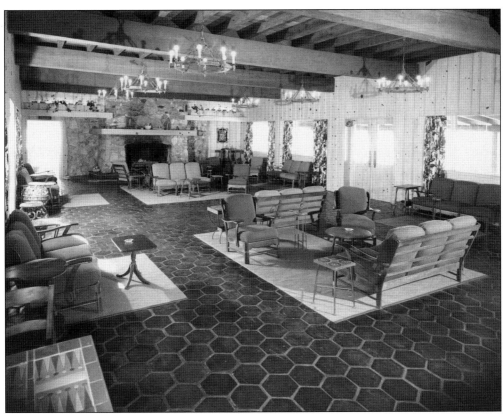

Once passengers stepped off the United Mainliner, they took in the views and soon discovered a charming airport terminal with a variety of amenities. A beautiful lounge equipped with comfortable seating, a large fireplace, and Catalina tile tables was a welcome respite for travelers. On the opposite side of the lounge was the United Airlines ticket and reservation counter. (Courtesy Santa Catalina Island Company.)

Air passengers and visitors to the Airport-in-the-Sky also enjoyed the lovely patio adjacent to the airport's administration building. The patio adorned in Catalina tile affords amazing views into the island's interior, where one might spot a buffalo or two while enjoying lunch. It is still today a favorite spot of residents and visitors. (Courtesy Santa Catalina Island Company.)

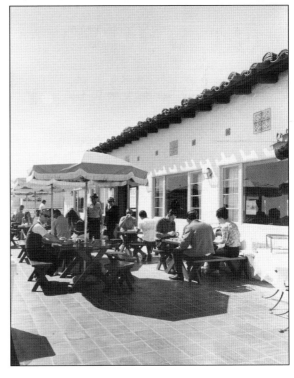

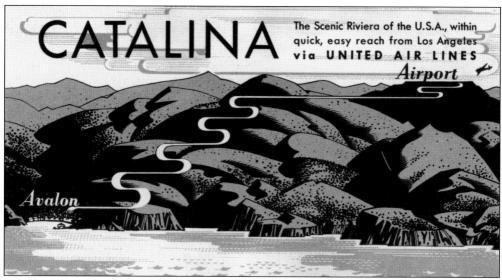

CATALINA

The Scenic Riviera of the U.S.A., within quick, easy reach from Los Angeles via UNITED AIR LINES

Airport

Avalon

Once passengers arrived at the Airport-in-the-Sky, they would board a motor stage for the drive to Avalon. According to a brochure printed by United Airlines, "Your Catalina flight and motor stage drive is one continuous scenic adventure—enjoyable all the way. Transferring to motor stage, at the airport, you see Catalina's scenic features in great detail as they are gradually revealed from unusual mountain-top vantage points along your way down to Avalon. There at sea level, still new scenic vistas await you!" (Courtesy Santa Catalina Island Company.)

The drive to Avalon via motor coach actually took longer than the trip via plane from the mainland, and many people thought it to be more adventurous than the flight. Passengers were deposited at the United Airlines office located at 204 Metropole Street, and from there, they would set off to explore the charming city of Avalon. (Courtesy Santa Catalina Island Company.)

Hugh T. "Bud" Smith, who was born and raised on Catalina Island and later served as the mayor of Avalon, was a pilot for United Airlines for 37 years and occasionally flew the Catalina route. Smith remembers, "The DC-3 Mainliner was a great plane to fly. We would make several trips a day, flying from Los Angeles to Long Beach and then to Catalina and we would make the same stops on the return trip. It seemed like we would be at it all day long." (Courtesy Hugh and Marie Smith.)

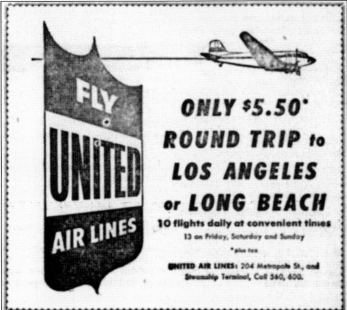

FLY
UNITED
AIR LINES

ONLY $5.50*
ROUND TRIP to
LOS ANGELES
or LONG BEACH

10 flights daily at convenient times
13 on Friday, Saturday and Sunday

*plus tax

UNITED AIR LINES: 204 Metropole St., and
Steamship Terminal, Call 560, 600.

United Airlines operated a regularly scheduled service to Catalina Island for seven years, providing residents and visitors with the modern convenience of land-based planes. In 1954, United announced that they would cease their operations on Catalina Island because of the specialized and seasonal nature of the traffic. The final United Airlines flight left Catalina Island on November 6, 1954.

Once United Airlines decided to cease their operations to Catalina Island, it was up to Catalina Air Transport, who managed the Airport-in-the-Sky, to find another airline to pick up the Catalina route. In April 1955, Catalina Airlines under the direction of Donald McBain, a former United Airlines pilot, inaugurated service to Catalina Island with De Havilland Dove airplanes.

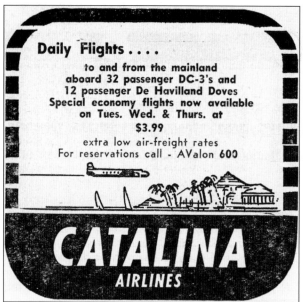

Catalina Airlines operated a regularly scheduled passenger service to Catalina Island from Torrance, Burbank, Los Angeles, and Palm Springs. They added a DC-3 to their fleet in 1957 and attempted to commence amphibian service between Los Angeles International Airport and Avalon Bay but met with opposition from the Avalon City Council. Catalina Airlines continued to operate from the Airport-in-the-Sky until 1959.

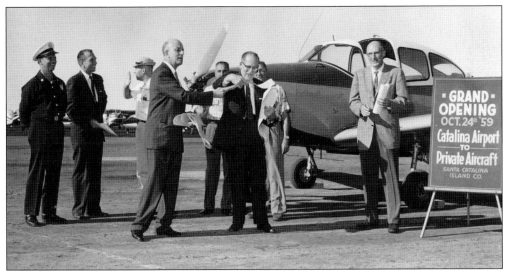

In 1959, the Airport-in-the-Sky was officially opened to private aircraft. Previously the airport was only available to those who leased land and facilities from the Santa Catalina Island Company. The decision to open the airport to private planes resulted from almost daily requests by private plane owners to land at the Airport-in-the-Sky. On October 24, 1959, forty privately owned planes landed at the airport to participate in the ceremony that opened Catalina's Airport-in-the-Sky to pilots around the world. (Courtesy Santa Catalina Island Company.)

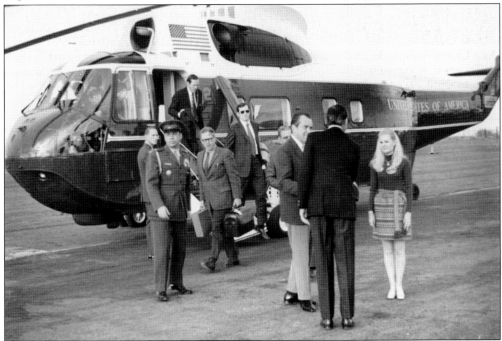

Many celebrities and dignitaries have flown through Catalina's Airport-in-the-Sky, including Richard Nixon. U.S. president Richard Nixon traveled to the island with his daughter, Tricia, in January 1971. It was a surprise visit; the mayor of Avalon learned of the visit 30 minutes prior to their arrival. President Nixon and Tricia toured Avalon and shook hands with many of the island's residents.

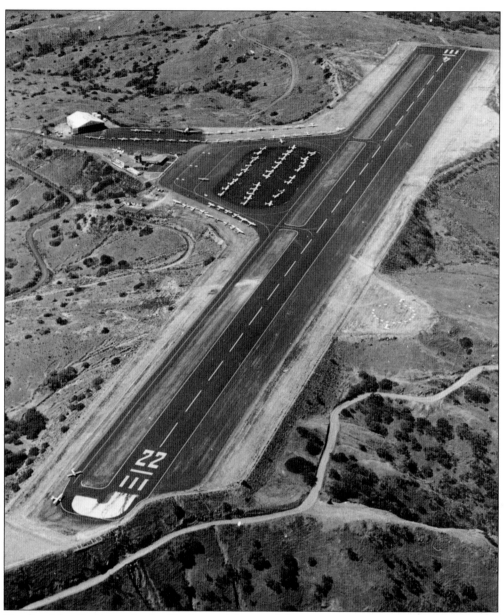

Catalina Island's Airport-in-the-Sky is certainly one of the most unique airports in the world. The mountaintop runway stretches 3,200 feet at an elevation of 1,580 feet, and it has one interesting feature that pilots often find challenging. The runway has a hump near the center, or one could say that the elevation of the runway changes; it is not completely flat. The wind generally blows out of the west into the east, and pilots most commonly land into the wind on runway 22. According to pilot Hugh T. "Bud" Smith, "It is better to land uphill because your stopping distance will be shorter, generally speaking. The runway is also often covered in fog and pilots have to circle around until they run out of gas or the fog clears." Today the Airport-in-the-Sky remains open to private planes and visitors. Several sightseeing tours originating in Avalon make stops at the airport everyday, and island residents often enjoy making the journey to the airport for lunch and the restaurant's famous "killer cookie." (Courtesy Santa Catalina Island Company.)

Five

The Seaplanes
are Back!

At the end of World War II, life on the island once again turned in favor of resort activities, and residents began to welcome back visitors from around the world. The steamships returned, but the Santa Catalina Island Company had abandoned their seaplane operation in favor of their new land-based plane activities at the Airport-in-the-Sky. However, by the summer of 1947, the roar of seaplanes returned to Avalon Bay and residents rejoiced. Amphibian Air Transport inaugurated service from Long Beach to Catalina Island in May 1947 with Grumman Goose amphibians. Amphibian Air Transport was organized in March 1947 by Robert J. Stewart, a former army pilot, with the aid of pilot Charles Hunsinger and businessman Kenneth Brown. The new airline purchased four Grumman Goose amphibians and set up operations at the Long Beach Municipal Airport. They initiated a regularly scheduled passenger service to the island with frequent daily trips at a cost of $6 each way per passenger.

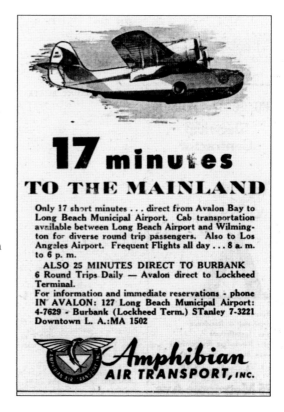

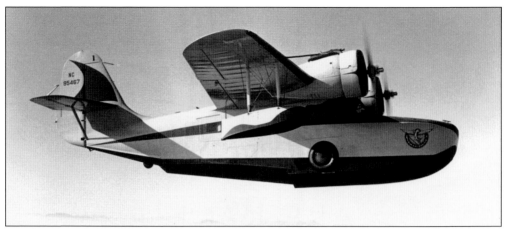

The introduction of the Grumman G-21 Goose to Catalina Island by Amphibian Air Transport commenced a new era in air service to the island. The Grumman Goose would become one the most beloved seaplanes in the island's history. The Goose was developed by the Grumman Aircraft Engineering Corporation in 1936 and was originally designed as a 10-seat commuter plane for businessmen in the Long Island area. The G-21's first flight occurred in June 1937. The amphibian was marketed to small air carriers and promoted as a military transport. (Courtesy Jay Guion.)

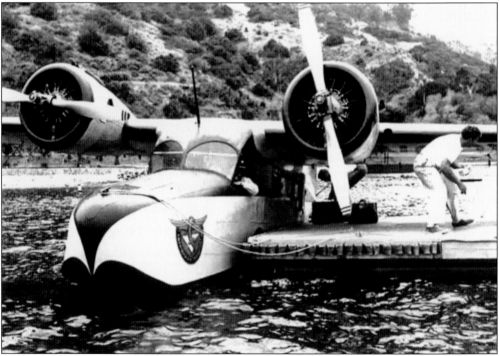

The arrival of World War II changed the fate of the Grumman Goose. The rugged amphibian was adopted by the U.S. Army Air Force, the U.S. Coast Guard, the Royal Canadian Air Force, and Britain's Royal Air Force. The Goose served in transport, reconnaissance, rescue, and training roles and was used for air-sea rescue. After the war, the surplus Gooses found their way into service with commercial operators worldwide, including Amphibian Air Transport's new service to Catalina Island.

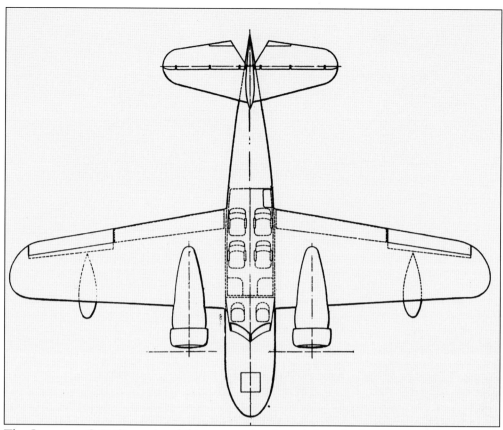

The Grumman G-21 Goose Amphibian was a closed amphibian, high-wing monoplane with an overall length of 38 feet, 4 inches, and a height of 12 feet. The wingspan equaled 49 feet with a wing area of 375 square feet. The G-21 was equipped with twin 450-horsepower Pratt and Whitney Wasp Jr. SB-2 air-cooled engines and could travel at a maximum speed of 184 miles per hour. Her features included a deep, two-step hull, full cantilevered wings, and a retractable undercarriage. A total of 345 Grumman G-21 Goose amphibians were built by the Grumman Aircraft Engineering Corporation between 1937 and 1945. (Courtesy Roger Meadows.)

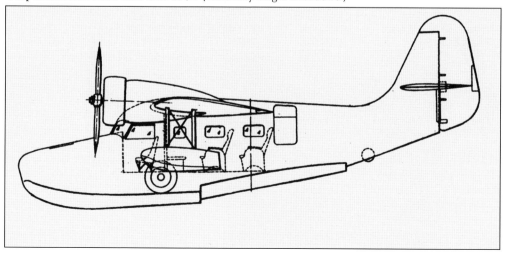

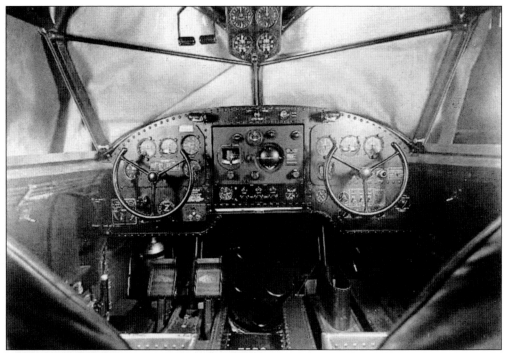

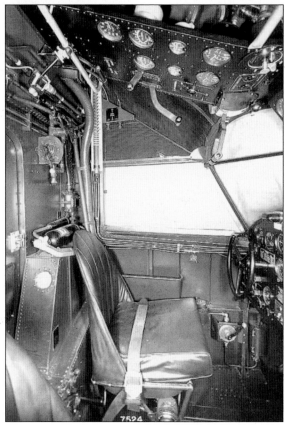

The interior of the Grumman G-21 Goose included two cockpit or pilot seats, up to nine passenger seats, and all the required avionic instrumentation, safety equipment, systems, and controls. Since the wings and engines of the Goose were placed high above the pilot's head, the throttle and several other key controls were mounted on the ceiling of the cockpit. The pilot sat on the left, operating the yoke with the left hand, the throttle and flaps with the right hand, and the rudder with his or her feet. (Courtesy Roger Meadows.)

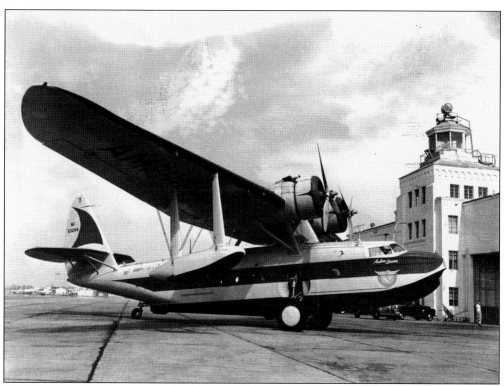

In addition to the Grumman Gooses, Amphibian Air Transport purchased a Sikorsky S-43 in 1947. The Sikorsky S-43 was a closed amphibian, high-wing monoplane with an overall length of 51 feet, 2 inches; a height of 17 feet, 8 inches; and a wingspan of 86 feet. She was equipped with two Pratt and Whitney R-1690 radial cooled engines, each with 750 horsepower. The large amphibian had a maximum speed of 190 miles per hour and carried up to 15 passengers. The Sikorsky S-43 that served Catalina Island was purchased from Inter Island Airways (now known as Hawaiian Airlines) and christened "Avalon Queen" by Amphibian Air Transport.

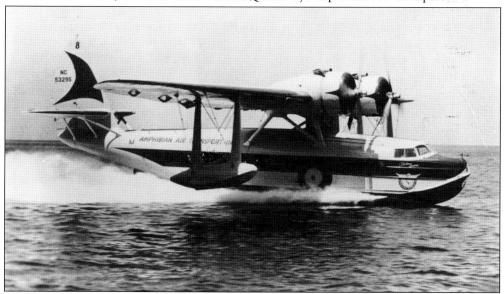

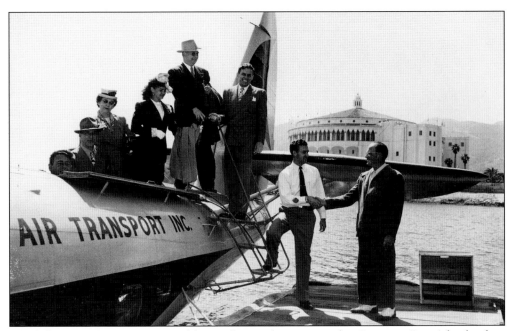

Amphibian Air Transport operated from a floating barge moored in Descanso Bay. After landing outside the bay, the seaplane would taxi to the float and unload passengers who would then be shuttled by boat to the pier. A unique ramp-barge was later employed by Amphibian Air Transport where the aircraft would pull itself out of the ocean from a steep, floating ramp up onto the barge. After unloading and loading, the aircraft would roll down the other side of the ramp and back into the ocean for its departure. Amphibian Air Transport served Catalina Island for 18 months, flying over 1,200,000 passenger miles in over 5,000 round-trips. They reluctantly ceased operations in September 1948 after problems arose with their Civil Aeronautics Board Certificate.

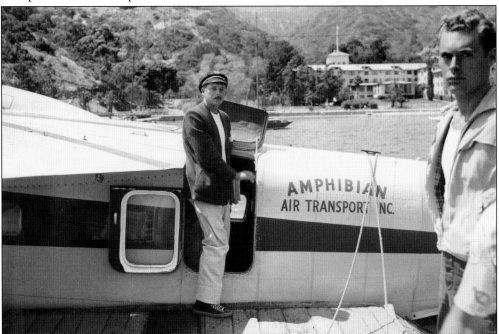

In 1947, famous air racing and movie stunt pilot Paul Mantz initiated a charter air service to Catalina Island. The Paul Mantz Catalina Air Service operated between Burbank Airport and Catalina Island offering charter flights to the mainland, scenic flights around the island, and charter flights to Toyon Bay, the isthmus, and Catalina's Airport-in-the-Sky. The air service operated from the Catalina Airport at Hamilton Beach.

Another Catalina air service initiated after World War II was California Maritime Airlines. The airline was organized by Edward Rickter, Charles Slocombe, and Harold Brown with the intention to provide intrastate air service to Catalina Island from Burbank, Long Beach, and San Diego with a 30-passenger PBY Catalina flying boat.

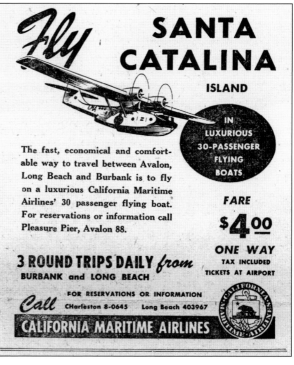

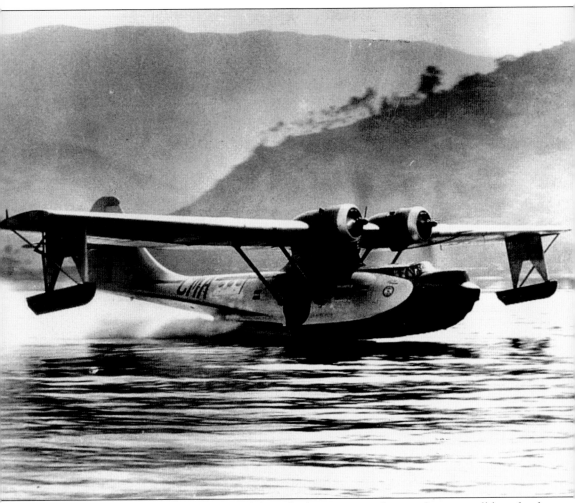

The PBY-5A Catalina was a closed amphibian, high-wing monoplane with an overall length of 63 feet, 10 inches; a height of 18 feet, 11 inches; and a 104-foot wingspan. It was powered by two Pratt and Whitney R 1830-92 Wasp radial cooled engines with 1,200 horsepower each and could travel at a maximum speed of 196 miles per hour. PBY was a U.S. Navy designation; PB meant patrol bomber and the Y was the manufacturer's designation. The name "Catalina" was given to the aircraft by the British Air Service. The PBY Catalina had an illustrious career as a military plane and was considered the most successful aircraft of its kind. No other flying boat was produced in greater numbers. The PBY Catalina was flown by California Maritime Airlines on a regular schedule from Long Beach and Burbank to Catalina Island for one year. (Courtesy Roger Meadows.)

Six

AVALON AIR TRANSPORT

Both airlines that initiated
amphibian air service to Catalina
Island after World War II had
ceased their operations by 1948. But
soon, a new airline would introduce
service and become one of the
longest running regularly scheduled
passenger air services in Catalina
history. Avalon Air Transport
was founded by pilot Wilton R.
"Dick" Probert and his partner,
Jean Chisholm, in the summer of
1953. Dick Probert was passionate
about aviation from an early age
and began flying at the age of 22.
He opened his own flying school
in Van Nuys, California, from
where Dick explored the sky above
Southern California by operating
charters and teaching students. The
business was going quite well until
the attack on Pearl Harbor basically
shut down Probert's operation.
Probert took a job with TWA for
a short time and then worked for
the Civil Aeronautic Association
until he accepted a position with
Consolidated-Vultee Aircraft
Company, who had a contract with
the military to transport personnel
and supplies. Dick flew converted
B-24 Liberator bombers to points all
over the South Pacific war zone.

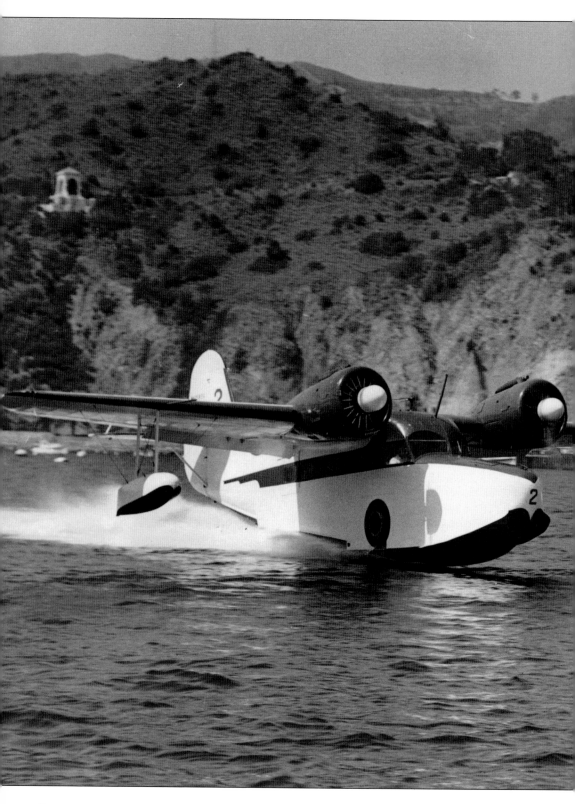

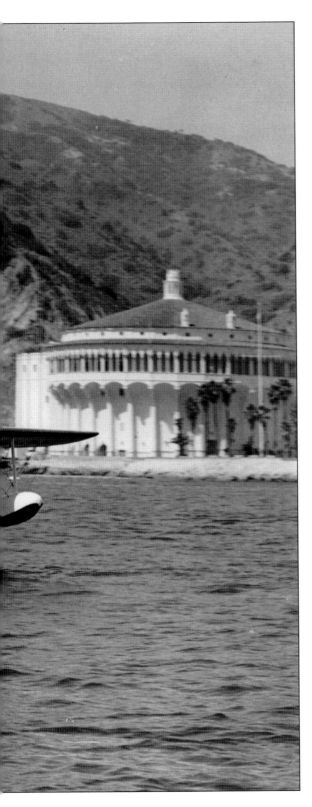

After the war, Dick Probert ventured back into private aviation and was soon introduced to the idea of starting an air service to Catalina Island by his friend Bob Hanley, who had previously worked as a pilot for Amphibian Air Transport. Excited by the idea, Probert and Hanley boarded the steamer for a trip to Catalina to discuss their plan with city officials. The island had been without seaplane service for five years, so they were met with great enthusiasm. Probert returned to the mainland in search of an airplane to begin his operation. He purchased a Grumman Goose from Cordova Airlines in Alaska with the help of his partner, Jean Chisholm, and incorporated his new business, Avalon Air Transport.

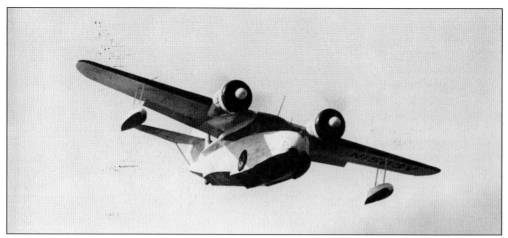

Avalon Air Transport commenced operations on August 27, 1953, with one Grumman Goose, two pilots, and a small office staff. According to the book *The Knights of Avalon* by David L. Johnston, "On the first day of operations only six passengers were carried. But that number doubled every day for a week. Soon, there were over 100 fare paying passengers per day." So the airline was virtually an instant success.

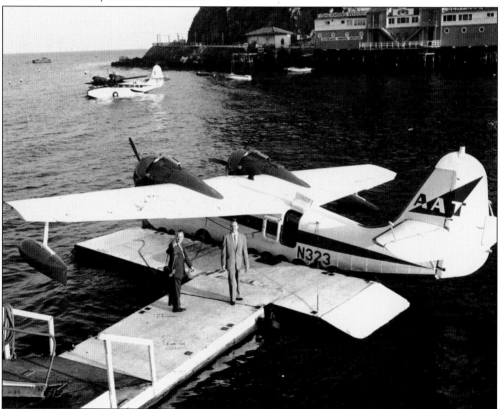

Initially the airline operated from a floating dock moored outside of Descanso Bay. Probert had obtained permission to operate out of Avalon Bay, but at the time, the Avalon harbor master was concerned that the seaplanes would interfere with boat traffic in the bay. However, it was not long before Avalon Air Transport moved their docking facilities to the end of the Pleasure Pier.

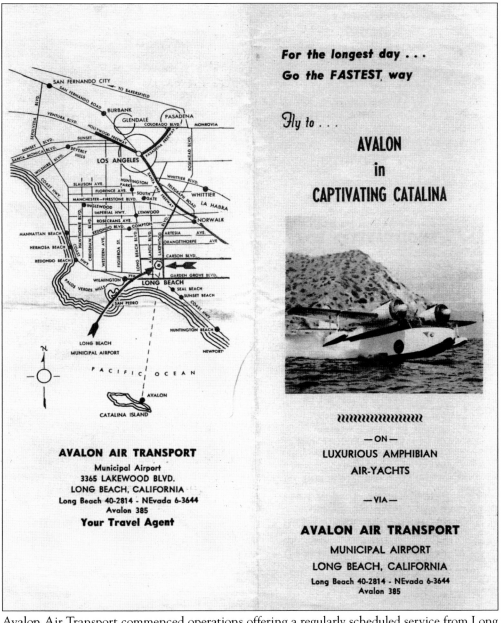

For the longest day . . .

Go the FASTEST way

Fly to . . .

AVALON
in
CAPTIVATING CATALINA

𝄂𝄂𝄂𝄂𝄂𝄂𝄂𝄂𝄂𝄂𝄂𝄂𝄂

— ON —

LUXURIOUS AMPHIBIAN

AIR-YACHTS

— VIA —

AVALON AIR TRANSPORT

MUNICIPAL AIRPORT

LONG BEACH, CALIFORNIA

Long Beach 40-2814 - NEvada 6-3644
Avalon 385

AVALON AIR TRANSPORT

Municipal Airport
3365 LAKEWOOD BLVD.
LONG BEACH, CALIFORNIA
Long Beach 40-2814 - NEvada 6-3644
Avalon 385
Your Travel Agent

Avalon Air Transport commenced operations offering a regularly scheduled service from Long Beach Municipal Airport to Catalina Island with eight flights per day. The air service quickly became popular. Within their first year of operation, the company carried over 26,000 passengers in 900,000 passenger miles. According to a September 2, 1954, article in the *Catalina Islander*, "The Avalon Air Transport service is the fastest to the mainland yet provided for Islanders and tourists, as they make the trip between Avalon and Long Beach in 17 minutes." The air service provided a quick, convenient, and safe link to the mainland, which was greatly appreciated by island residents and visitors. The service proved even more crucial since shortly after the airline celebrated their first year of service, United Airlines ceased their operations at the Airport-in-the-Sky, leaving Avalon Air Transport as the only air service to the island for the next few years. (Courtesy Roger Meadows.)

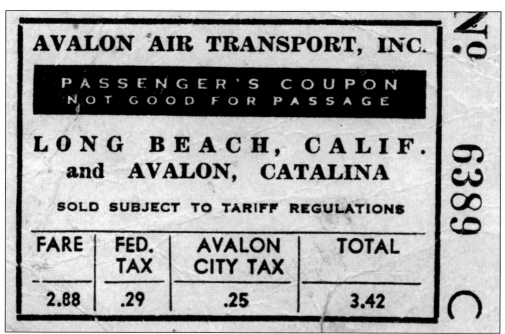

By 1954, Avalon Air Transport's business was growing rapidly and Dick Probert decided that he needed some help, so he approached friend Walt Von Kleinsmid. Probert knew that Walt had a flair for running a business and asked him to become his managing partner. Von Kleinsmid purchased 50 percent of Jean Chisholm's stock and went to work with Probert to build and manage their business. Avalon Air Transport soon expanded their fleet, began carrying freight, and received a contract to carry U.S. mail.

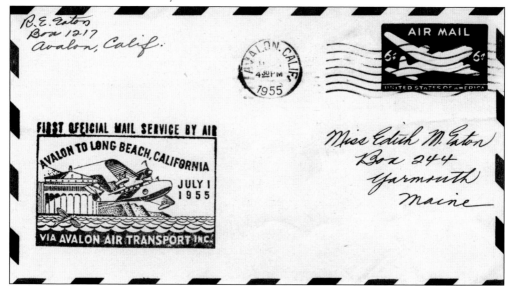

In June 1955, the U.S. Postal Service awarded Avalon Air Transport a contract to carry all classes of U.S. mail between Long Beach Municipal Airport and Avalon. The mail was carried on a schedule of six round-trips per week, exclusive of holidays. A special flight was added to Avalon Air Transport's schedule since the volume of mail was too great to be handled on a regular passenger flight. This contract marked the first official regular air mail service in Catalina's history.

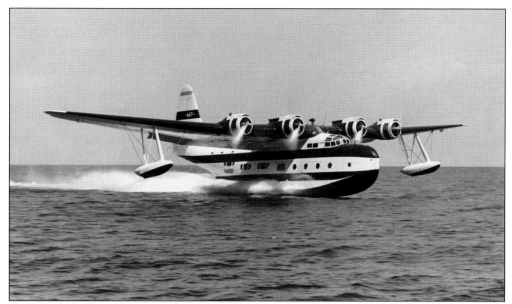

By 1957, Avalon Air Transport was operating a fleet of seven Grumman Gooses on the Catalina run, but Probert and Von Kleinsmid still felt there was enough business and opportunity to expand further. Probert went in search of a large flying boat that could accommodate more passengers. Probert found a Sikorsky VS-44A flying boat, which had been previously flown by the U.S. Navy and American Export Airlines.

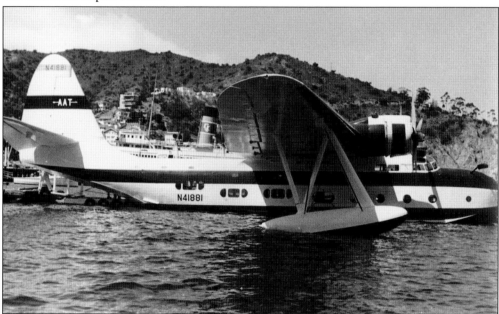

Before being purchased by Avalon Air Transport, the Sikorsky VS-44A flying boat was last operated by Skyways International Trading Company. Skyways was a group a Baltimore businessmen who planned to use the aircraft as a "flying trading post," carrying freight to natives at the mouth of the Amazon River. However, their plan failed and the flying boat was abandoned in Ancon Harbor, near Lima, Peru. Probert traveled to Peru and upon inspection of the flying boat decided that it would make a splendid addition to his fleet.

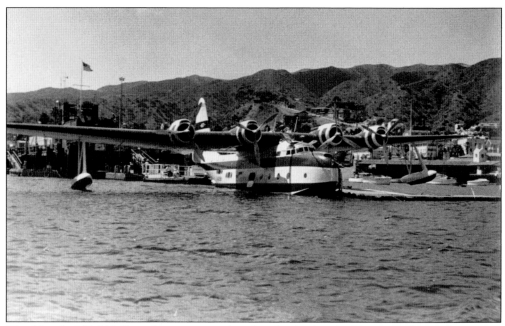

The Sikorsky VS-44A flying boat was introduced to the Avalon Air Transport fleet in September 1957 and was dubbed the "Mother Goose." According to an article in the *Catalina Islander* on September 19, 1957, "The huge luxury flying boat has been maintained in first class condition and safety is one of its most important basic features. Due to its construction, it can glide to a water landing without any of its four engines operating. It can maintain flight fully loaded on any two of its four engines and the design of this flying boat makes it very seaworthy for landing in rough water. The interior has been recently refurbished and refitted with a luxury appearance and 46 comfortable seats throughout the main cabin. The crew of captain, co-pilot, engineer, and steward are on the flight deck in the nose of the ship."

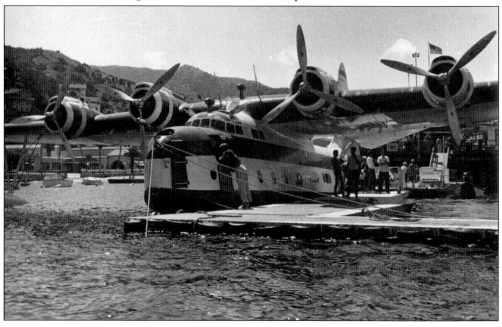

The Sikorsky VS-44A "Mother Goose" was 76 feet, 3 inches in length with a wingspan of 124 feet. She was equipped with four Pratt and Whitney engines with 1,250 horsepower each and could reach a maximum speed of 220 miles per hour. The "Mother Goose" also had several storage compartments in her wings where passenger luggage and freight could be stored.

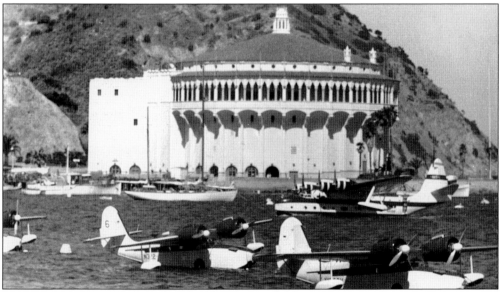

The "Mother Goose" became the flagship of Avalon Air Transport and served on the Catalina run for 10 years, carrying thousands of passengers across the San Pedro Channel. In 1968, the Sikorsky VS-44A was sold to Antilles Airboats in the Virgin Islands, and later that year, the ship was damaged beyond repair and retired from service. The Sikorsky was later donated to the Naval Aviation Museum in Pensacola, Florida, and today can be found on display at the New England Air Museum in Windsor Locks, Connecticut.

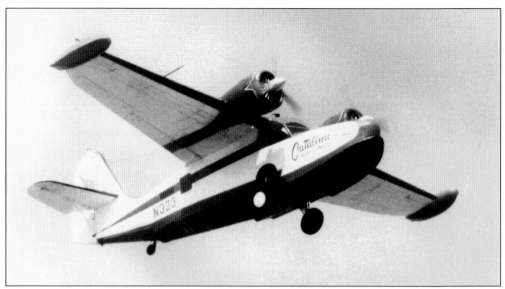

By the summer of 1960, Avalon Air Transport's business had grown to include seven Grumman Gooses, the Sikorsky VS-44A "Mother Goose," and two DC-3 aircraft. The Grumman Gooses operated between Long Beach Municipal Airport and Avalon Bay while the Mother Goose operated between Long Beach Harbor and Avalon Bay. The newly added DC-3 service operated between Burbank, Los Angeles International Airport, Long Beach Airport, and the Airport-in-the-Sky. In 1963, Avalon Air Transport officially changed its name to Catalina Air Lines. (Courtesy Dennis Buehn.)

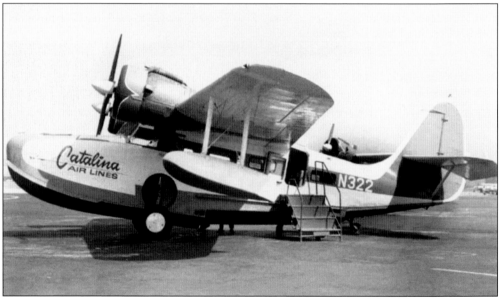

Catalina Air Lines celebrated its 10th year of service in 1963. According to an October 3, 1963, article in the *Catalina Islander*, "The summer of 1963 produced several new records for the airline. On Sunday afternoon, August 25th, the airline carried 1,118 people, an all time record. The airline has proved air transportation to be one of the prime cross channel movers, between April 26th and September 30th, 65,401 persons were carried across the channel by the air service." (Courtesy Roger Meadows.)

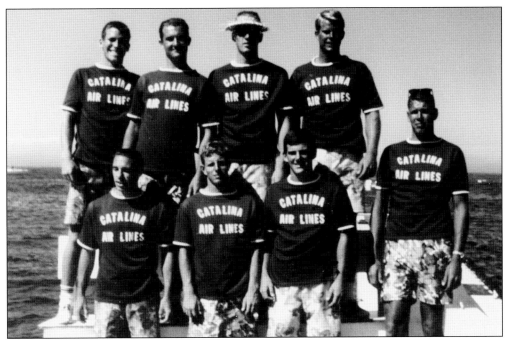

During their 15 years of operation, Catalina Air Lines employed hundreds of personnel from pilots, stewardesses, mechanics, and station personnel to dock boys. This photograph depicts a typical Catalina Air Lines "dock-boy" crew in the mid-1960s. Pictured from left to right are (first row) David "DJ" Johnston, John Lewis, Tom "Devil Eyes" Davoli, and Bill "Stork" Harvey; (second row) Mike Harris, David "DT" Turner, Greg "Mad Gorgen" Madden, and Greg "Babe Magnet" Harris. (Courtesy David L. Johnston.)

This dock-boy crew worked in the middle of Avalon Bay on the seaplane floats that extended from the Pleasure Pier. Every day of the week, they handled up to seven Grumman Gooses and the Sikorsky flying boat—dealing with mail, freight, and hundreds of passengers and their luggage. They all thoroughly enjoyed their jobs and have many fond memories of spending their summers working for Catalina Air Lines. (Courtesy David L. Johnston.)

According to former Catalina Air Lines employee David L. Johnston, "The annual Catalina Air Lines company party was held at any location where all employees could celebrate in style. It might be the Zane Grey Pueblo, the Catalina Country Club, or the Malibu Inn [above]. Pilots, wives, station personnel, mechanics, reservation agents, ramp agents and dock boys all came." (Courtesy David L. Johnston.)

The seaplane pilots of Catalina were all highly qualified and skilled pilots, each with tremendous experience and flying time. They had a larger-than-life persona and are often remembered as the "cowboys of the air." Lloyd "Jugs" Burkhard (pictured here) flew for Catalina Air Lines for many years and loved to fly the "Mother Goose." Some of his fellow pilots included Warren Stoner, Fred Pierce, Clarence Jasper, and Bill Kilgour, to name a few. (Courtesy Roger Meadows.)

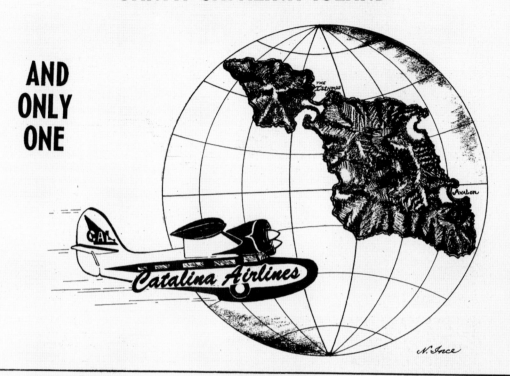

IN ALL THE WORLD THERE IS ONLY ONE
SANTA CATALINA ISLAND

AND ONLY ONE

Catalina Airlines

N. Ince

LEAVE AVALON	JUST CALL	LEAVE LONG BEACH
8:30 & 10:00 A.M.		8:00, 9:30 & 11:00 A.M.
1:30, 3:30, 4:30 & 5:30 P.M	**385**	2:00, 4:00 & 5:00 P.M.
	SEVEN DAYS A WEEK	

One of Catalina Air Lines' most loved employees was Dick Probert's wife, Nancy Ince Probert. Nancy grew up in Hollywood, and her grandfather was Thomas Harper Ince, a well-known movie producer. Nancy's mother, Dorothy Kitchen (who later changed her name to Nancy Drexel), was an actress who appeared in a variety of motion pictures throughout the 1920s. As a young girl, Nancy would sail to Catalina aboard her father's yacht. One day when Nancy was trying to reach the island to meet up with her family, she boarded an Avalon Air Transport Grumman Goose with Dick Probert as her pilot. Two years later, Nancy was hired by Avalon Air Transport as a ticket agent at the Long Beach Airport. She quickly made quite an impression on the passengers, the airport, and especially on Dick Probert. In 1957, when the "Mother Goose" was introduced to the fleet, Dick Probert decided to add a stewardess to their service, and Nancy was the obvious choice. Nancy served as the chief stewardess for the airline and recorded 3,589 round-trips in 10 years. She also was a talented artist and created many of the airline's advertisements, including the one above.

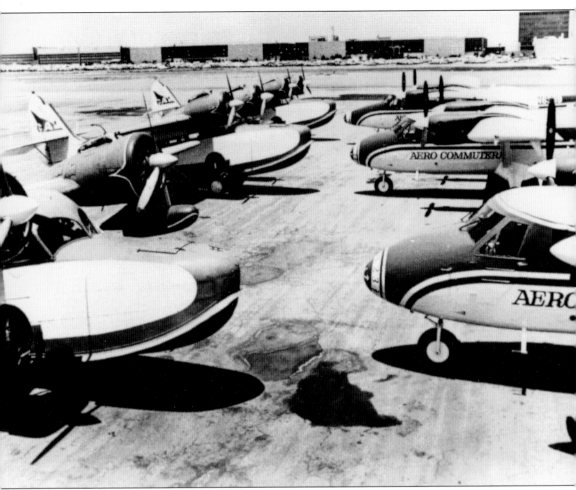

Catalina Air Lines continued operations under the direction of Dick Probert and Walt Von Kleinsmid until 1968, when the airline was sold to members of the William L. Pereira family. In their 14 years of service, the airline carried over 900,000 passengers. It was the first airline to carry mail to Catalina and the first airline to serve Catalina with land planes, amphibian planes, and seaplanes. It was one of the longest running and most successful airlines in Catalina history. Beginning in January 1968, the Pereira family continued amphibian service to the island and expanded the operation to include 18-passenger De Havilland Twin Otter airplanes. The new service was called Aero Commuter and operated daily flights between Los Angeles International Airport, Long Beach Airport, Fullerton Municipal Airport, and Catalina's Airport-in-the-Sky. Catalina Air Lines and Aero Commuter were later purchased by the Westgate-California Corporation, and the name was changed to Golden West Airlines, Inc., to reflect the growing statewide operation of the airline. (Courtesy Roger Meadows.)

Seven

It's a Bird, It's a Plane!

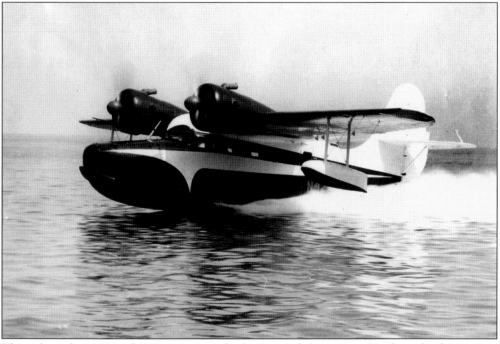

Throughout the 1960s and 1970s, a variety of airlines provided service to Catalina Island. Longtime island resident Doug Bombard remembers, "It was a great era; it was great transportation for the Island and it was fun!" The option of quick transportation to the island for residents and visitors was especially crucial during this time because the island's regularly scheduled water transportation was beginning to experience some challenges. It was the era of seaplanes, and many people fondly remember riding the Gooses across the channel. One airline that provided excellent service during the late 1950s and 1960s was Catalina Channel Airlines. Founded in 1959 by Bob Hanley, Catalina Channel Airlines was known as the "Executive Service." Hanley was a pilot who had previously flown for Amphibian Air Transport and Avalon Air Transport. In fact, it was Bob who introduced the idea of starting an airline on Catalina Island to Dick Probert, the owner of Avalon Air Transport. Bob Hanley was well liked by the residents of Avalon, who knew him as an excellent pilot and true gentleman. (Courtesy Dennis Buehn.)

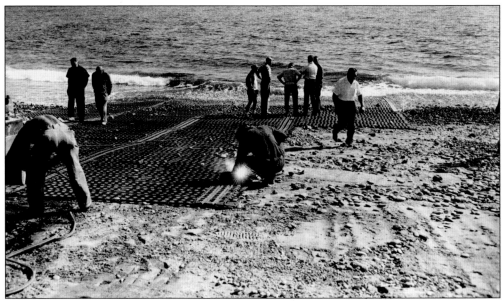

Catalina Channel Airlines operated from the newly constructed seaplane ramp at Pebbly Beach, located about one mile south of the city of Avalon. Catalina Airlines initiated the plans for the new airport facility in 1958. Originally Catalina Airlines planned to develop a runway large enough to accommodate their land-based planes as well as their amphibians. They also planned to build a modern passenger terminal, an air freight terminal, and a restaurant at the site. (Courtesy Santa Catalina Island Company.)

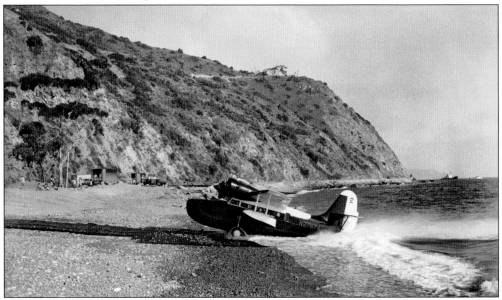

The "Airport by the Sea" as proposed by Catalina Airlines was never built, but a concrete seaplane ramp was constructed and Catalina Channel Airlines inaugurated service from the new Pebbly Beach Airport. According to an article in the *Catalina Islander* on June 25, 1959, "The Pebbly Beach facility includes the airline's main office, a large paved apron and a temporary ramp. Construction of a permanent temporary ramp has been delayed until a later date because of labor and transportation problems." (Courtesy Santa Catalina Island Company.)

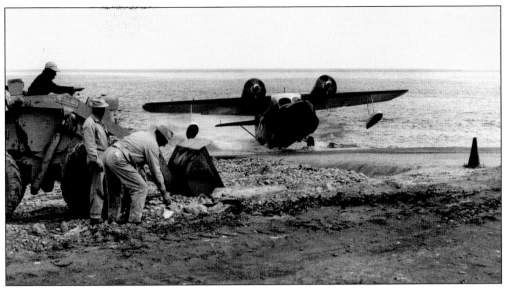

Catalina Channel Airlines operated from the temporary ramp for a short time until a permanent concrete ramp was constructed. The airline began operations with two reconditioned Grumman Gooses and later added a third. The Gooses operated on a regular schedule between Long Beach Municipal Airport and the Pebbly Beach facility. (Courtesy Santa Catalina Island Company.)

Bob Hanley proudly advertised his new air service as "Fly the Executive Way." According to a September 10, 1959, article in the *Catalina Islander*, "Mr. Hanley states that the airline plans to maintain a high standard of executive service for the convenience of Islanders, while enabling tourists to get an important first impression of Catalina."

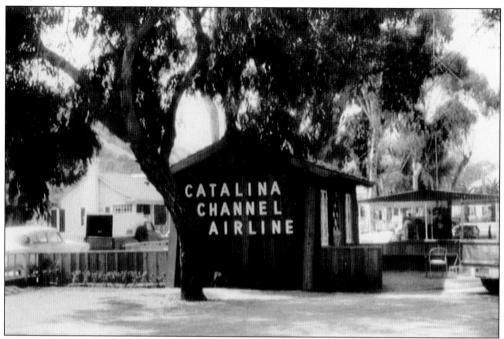

Catalina Channel Airlines island operations consisted of a main office at Pebbly Beach and an office and waiting room between Catalina Avenue and the Island Plaza in Avalon. The airline operated red Volkswagen buses that shuttled passengers and their luggage door-to-door. Longtime island resident John Phelps served as the station manager for Catalina Channel Airlines from 1959 until 1962 and can still recall the fares with ease: "It was $5.63 one way, $11.26 round trip and $22.52 for two round trips. You could also charter a Grumman Goose for nine people to Long Beach for $55.00." John remembers, "It was a wonderful, good time. I enjoyed the whole thing and it was great transportation for the island." Catalina Channel Airlines served the island on a regular schedule until 1966. (Both courtesy Roger Meadows.)

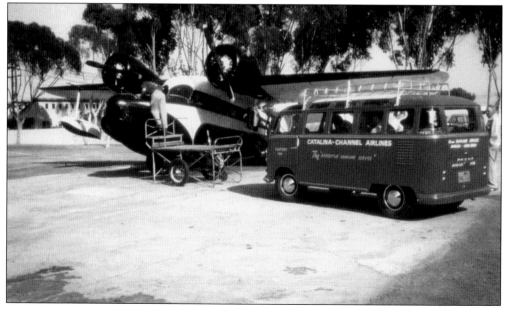

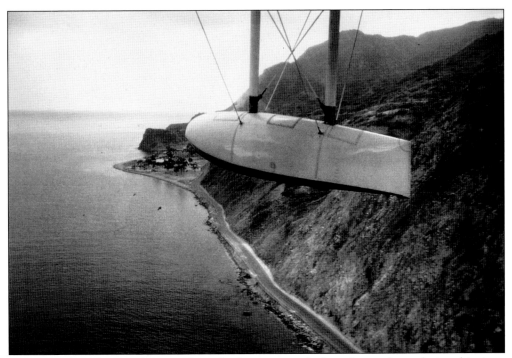

Many island residents and visitors have fond memories of riding the seaplanes during this time. And in some cases, the seaplanes provided another crucial service to locals. Island resident Bill Jones remembers, "Catalina Channel Airlines saved my son's life. My son had a serious head injury and they flew him over to Long Beach at no charge. I really appreciated that because he could have died and I wouldn't now have my three grandchildren." (Courtesy Roger Meadows.)

In addition to their Avalon service, Catalina Channel Airlines served the island's hunting operation. They flew hunters directly to the island's hunting lodge at Toyon Bay. In later years, the seaplanes served as the primary transportation for the island's hunters. The hunting operation moved to Two Harbors, and the seaplanes would transport hunters direct from the mainland to Catalina Harbor. On the return trip, the seaplanes carried the hunters as well as their game.

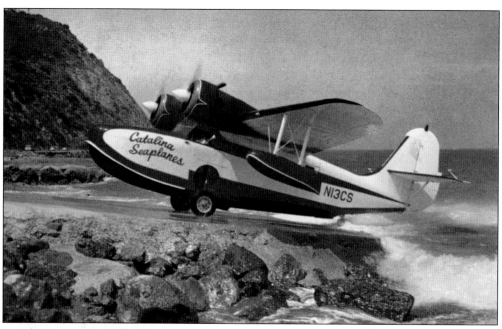

Catalina Seaplanes, Inc., began operations in 1966 as a subsidiary of MGRS, a Los Angeles Harbor sightseeing company. Catalina Seaplanes operated under the general management of Dick Probert, who previously owned Avalon Air Transport and provided service from San Pedro, California, to Catalina's Pebbly Beach airport. The airline flew three Grumman Goose seaplanes painted in a beautiful red, white, and blue scheme.

Catalina Seaplanes operated from a terminal in Los Angeles Harbor adjacent to the island's steamship terminal. Known as "Catalina's Sea and Air Gateway Terminal," it was quite convenient for passengers with easy access to bus services and the Harbor Freeway.

This brochure for Catalina Seaplanes describes the company as a "Certificated Scheduled Commuter Air Line which has safely flown over 500,000 passengers between the mainland and Catalina Island since 1966. Its amphibious aircraft are maintained in the company's F.A.A. Approved Repair Station to the highest safety standards possible. Each aircraft is equipped with complete instrumentation and radio for all-weather operations. They have sound-proof interiors, high-backed comfortable seats, large panoramic windows. . . . all these are yours on your Catalina Seaplanes flight—as well as the latest in safety devices. After an exhilarating take off and water landing you will enjoy the convenience of disembarking on land." Catalina Seaplanes flew up to 10 flights per day during the busy summer season, leaving San Pedro every hour on the hour and leaving Avalon on the half hour. The trip by air would take between 10 and 12 minutes. Catalina Seaplanes served Catalina Island until 1972.

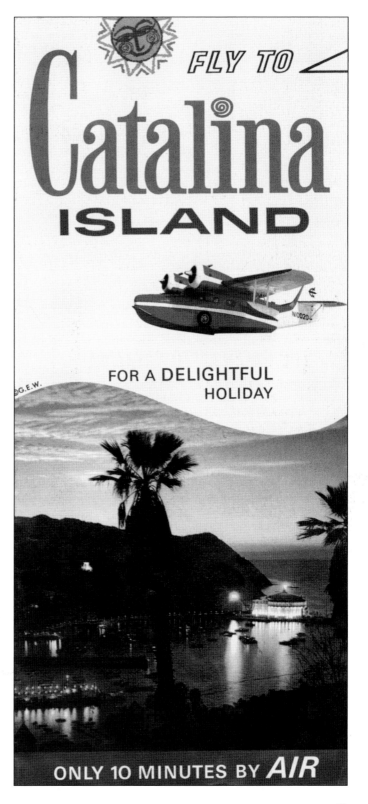

FLY TO

Catalina ISLAND

FOR A DELIGHTFUL HOLIDAY

ONLY 10 MINUTES BY *AIR*

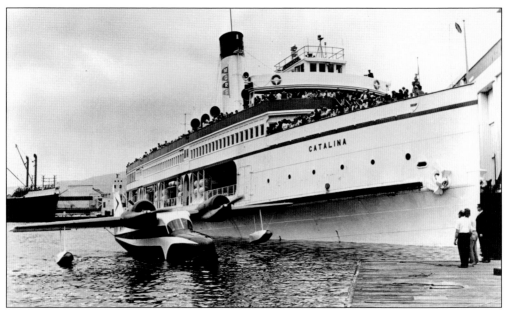

Many island residents and visitors fondly remember riding the Grumman Goose seaplanes. Island resident Roger Meadows remembers, "The school would charter the seaplanes for the basketball team because it was cheaper than taking the boat. I was the manager for the team. It was late February and real stormy. The winds were blowing and it was raining, but we had to get over to the mainland or we would have to forfeit the game. We took off and it was like riding a bucking bronco. We made it to the mainland and unfortunately lost the game, but I will never forget that ride." Meadows later became an avid seaplane enthusiast and recalls, "There is nothing like the sound of a Grumman Goose taking off, but also there is nothing like the smell of a Grumman Goose. It has a distinct smell and you know it's a Goose. It was such a great aircraft!"

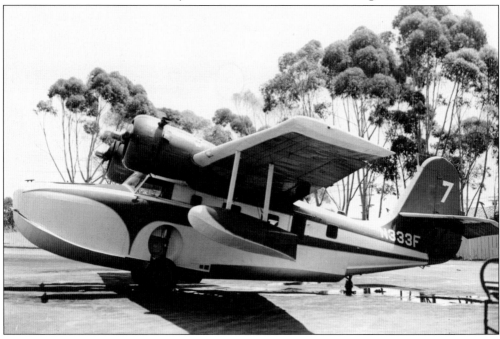

Robert Sherrill remembers, "When I was a kid, Dick Probert flew the seaplanes. My parents owned the repair barge and we flew back and forth a lot. One day, Probert got in the back of the plane and we sat there for a few minutes and people started grumbling, where is the pilot? Then I remember him jumping up from the back of the plane and saying 'Well, hell. . . . I guess I'll fly the plane!' The passengers didn't realize that he was the pilot and started to get out of the plane." Probert was just kidding around, as many of the pilots often did. (Courtesy Dennis Buehn.)

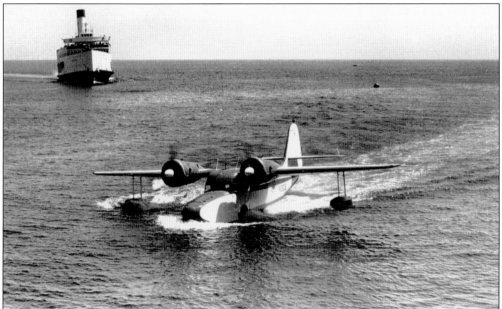

Katie Cotter remembers that her dad would often commute to the mainland aboard the seaplanes, and "Mom would say 'Your Dad is coming home from work, go watch for him.' That meant that I should sit in the corner of the living room with binoculars. When a seaplane would fly by our window and land I would use the binoculars to see who got off the plane." (Courtesy Roger Meadows.)

Holiday Ways was a short-lived air service that operated between California's San Gabriel Valley and Catalina's Airport-in-the-Sky. Flights originated from Brackett Field, near Pomona and Fullerton Airport. The air service offered regularly scheduled flights aboard two eight-passenger, twin-engine Beachcraft D-18s. The airline served Catalina Island for only one summer season in 1960.

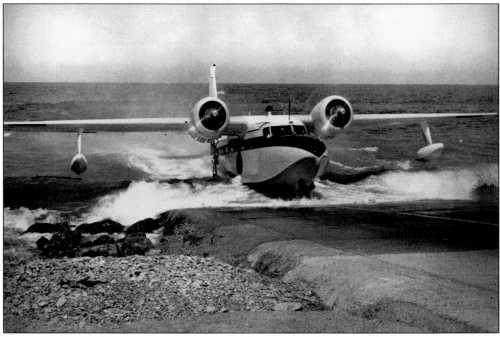

Catalina-Vegas Airlines inaugurated service to Catalina Island in 1962. The airline operated once daily between San Diego International Airport and Catalina Island. According to a *Catalina Islander* article on July 25, 1963, "Air service between Santa Catalina Island and San Diego has been attempted several times. Present operations of Catalina-Vegas Airlines appear here to stay providing a dependable form of long needed transportation."

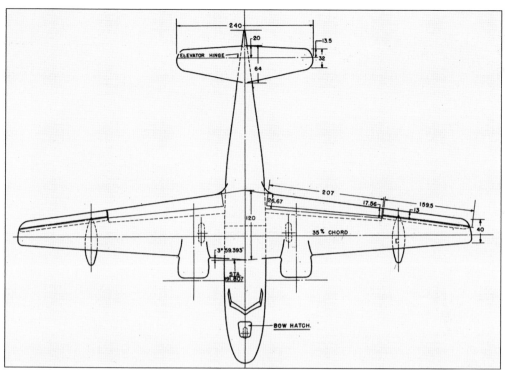

Catalina-Vegas Airlines operated Grumman G-73 Mallards. The Mallards were a large, twin-engine amphibious aircraft designed by Grumman Aircraft Engineering Corporation for commercial use. The Mallard was 48 feet, 4 inches in length and 18 feet, 9 inches in height. The wingspan reached 66 feet and 8 inches, and the aircraft could accommodate up to 17 passengers. (Courtesy Roger Meadows.)

In 1965, Catalina-Vegas Airlines added service between Orange County Airport and Catalina Island's Pebbly Beach Airport. The airline also operated daily flights and excursions between San Diego and Tijuana, Mexico. Catalina-Vegas Airlines served Catalina Island until the mid-1970s but then picked up service again in the mid-1980s for a short time.

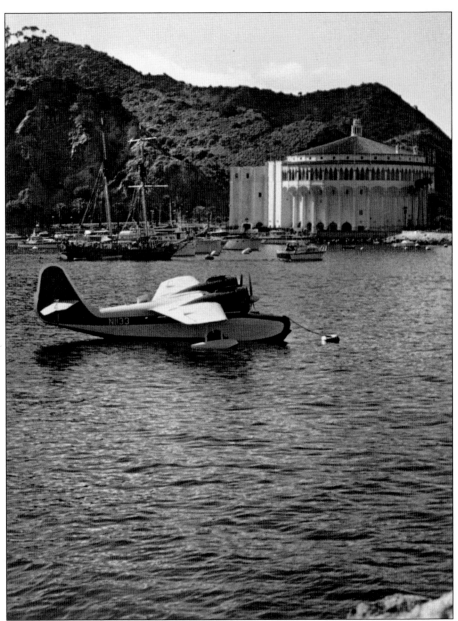

Golden West Airlines, a subsidiary of Westgate-California Corporation, purchased Catalina Airlines and Aero Commuter from Dick Probert in 1968 and took over their Catalina service. At the time, Golden West Airlines was a busy commuter airline operating flights throughout the state of California. Based at the Los Angeles International Airport and Long Beach Municipal Airport, Golden West Airlines operated flights to San Diego, Palm Springs, Palmdale, Oceanside, Sacramento, Santa Barbara, Sacramento, and Catalina Island. Golden West Airlines offered service to Avalon via the Long Beach Airport aboard Grumman Goose amphibians and service to Catalina's Airport-in-the-Sky from the Los Angeles International Airport, Palomar Airport, and Orange County Airport aboard De Havilland Twin Otter aircraft. The airline served Catalina Island on a regular schedule until 1973 and continued their other commuter lines throughout the state until 1984.

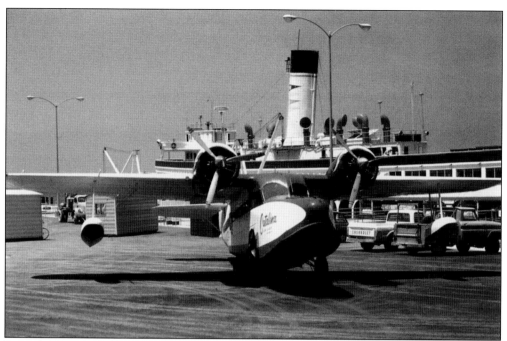

For a short time, Golden West Airlines operated from a seaplane ramp at Avalon's new Cabrillo Mole. The Cabrillo Mole was built after the long-standing steamer pier was dismantled in the late 1960s. The Mole was part of an overall plan for harbor improvement by the City of Avalon and was designed as a docking facility for several ships. A seaplane ramp was constructed on the Lover's Cove side of the Mole. (Courtesy Roger Meadows.)

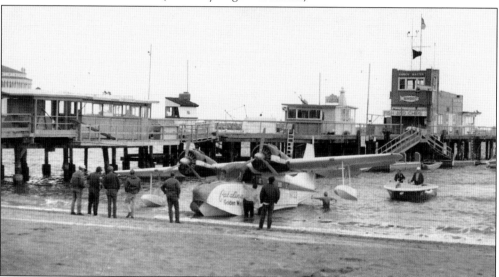

A rare sight indeed is a seaplane on the beach in Avalon! This had not happened since Glenn Martin landed his biplane on the same beach in 1911. This Golden West Airline's Grumman Goose was not trying to relive the past but rather was experiencing mechanical difficulties after a landing outside the bay, and the pilot decided to taxi through the harbor and up to dry land for safety. The seaplane remained on the beach for several days until mechanics sorted out the problem. (Courtesy Roger Meadows.)

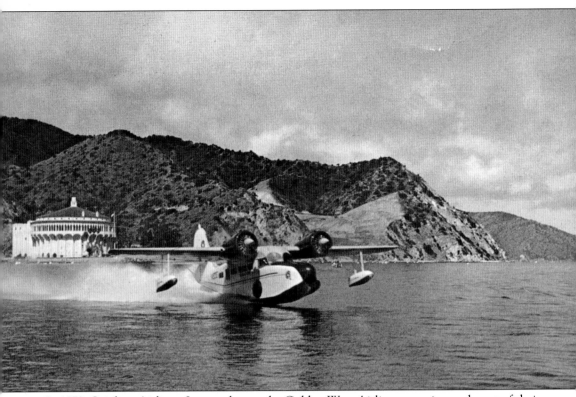

In 1973, Catalina Airlines, Inc., took over the Golden West Airline operation and most of their Grumman Goose fleet. Catalina Airlines, under the direction of president and general manager K. C. Van der Reit, operated five Grumman Goose seaplanes with a green and copper paint scheme. The airline operated between Long Beach Municipal Airport and Catalina's Pebbly Beach airport on a regular schedule. Catalina Airlines was later sold to Paul Briles in 1977. At this time, the airline started to experience difficulty when the FAA temporarily grounded its fleet of seaplanes for extensive corrosion. The Grumman Goose seaplanes were especially vulnerable to corrosion because of their exposure to saltwater, and by this time, the Gooses were considered vintage aircraft. Briles augmented his Catalina service with the introduction of helicopters to the Catalina run and worked hard to bring his seaplanes up to FAA standards. Catalina Air Lines, Inc., served Catalina Island on a regular schedule until 1981.

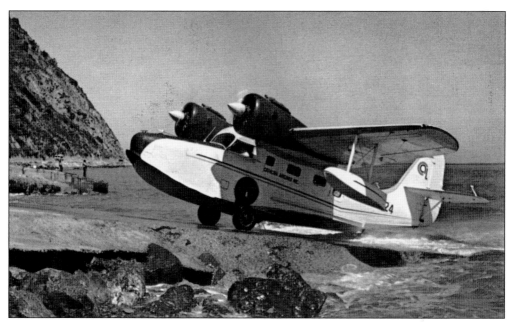

Many island residents remember the "green seaplanes" of Catalina Airlines, Inc. Longtime island resident Frank Saldana once remembered, "I was working for the airline and I really had a good time out there. One of the most exciting days I ever had was when we carried 800 people. We also had one pilot who would come around and say goodnight to us. He would fly over the treetops and then right over the ticket office. It was my buddy, Jim Thompson!"

Island resident Vernon Lopez remembers, "One day pilot Vern McGee was bored so he decided to drive the bus that shuttled passengers. He drove a bunch of people from town to the Pebbly Beach airport and after he offloaded the passengers, he got out of the bus and into the pilot seat of the plane. The passengers said 'I thought you were the bus driver?' And he said, 'I always wanted to fly one of these things and I think I can do it.' " (Courtesy Santa Catalina Island Company.)

Pilot

Captain Rex Cotter

Berth 95-96 • P.O.Box 207
San Pedro, California 90733
(213) 548-6767

Rex Cotter grew up on Catalina and had always been fascinated by the island's seaplanes. He often flew the seaplanes with his family, and after a trip to England aboard a Pan AM Boeing 707 at the age of 10, Rex decided that he would be a pilot. After graduating from Avalon High School, he attended Rangley College in Colorado where he learned to fly. Rex returned to Catalina Island with hopes of being a seaplane pilot. At this time, Trans Catalina Airlines had just started operations, and they flew Grumman Mallards. This was Rex's lucky break; he needed to gain flying experience, and for the first time in Catalina's seaplane history, the airlines needed copilots. Rex gained valuable experience flying with Trans Catalina Airlines and was later hired by Catalina Airlines as a pilot. During his Goose training with Catalina Airlines, it was standard procedure that before he could go solo, he had to fly with every captain. These Goose pilots had decades of flying experience. Rex soaked up their knowledge and became a highly skilled pilot in his own right. Today Captain Cotter is a pilot for Kalitta Air, LLC. He flies Boeing 747s for the international heavy-lift cargo company to points around the world. (Courtesy Roger Meadows.)

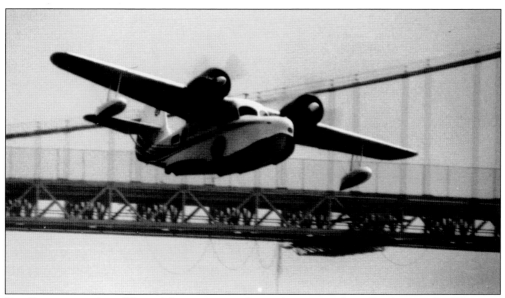

Rex Cotter remembers, "One of the greatest seaplane pilots to ever fly to Catalina was Jaz (Clarence Jasper). He told me that the airports (Long Beach and Orange County) are always the same, in the same place, but the water on Catalina was different every time you landed. One day while I was still in training with Jaz, we left Avalon on our way to San Pedro and we couldn't see where we were. We'd been in the air for 17 minutes and we couldn't see anything. When I asked him if he knew where we were, he turned to me and said in this gravelly voice, 'Don't worry!' All of a sudden a hole opens up and it's just North of the Vincent Thomas Bridge. He pulls back the throttles, full flaps, and dives through the hole and lands safely. I just don't know how these guys did it. They found the island; they found San Pedro, with no assistance whatsoever." (Courtesy Briles family.)

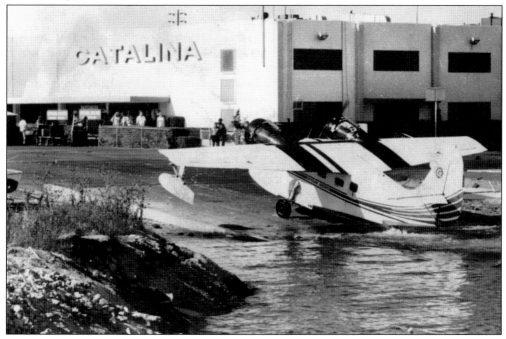

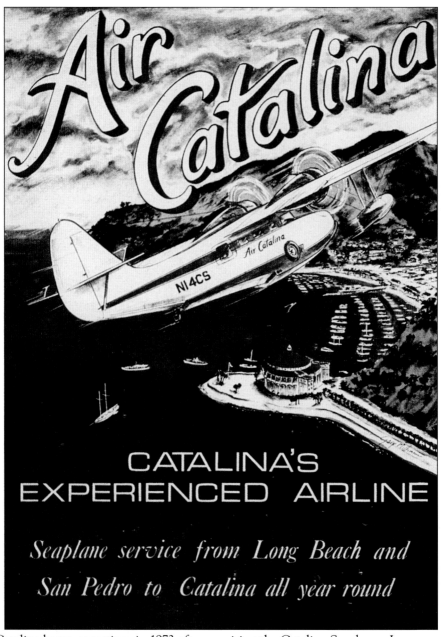

Air Catalina

CATALINA'S EXPERIENCED AIRLINE

Seaplane service from Long Beach and San Pedro to Catalina all year round

Air Catalina began operations in 1973 after acquiring the Catalina Seaplanes, Inc., name and fleet. Pres. Jackson Hughes released the following statement upon his purchase of the airline: "We are Air Catalina and we feel fortunate to be able to step into the large footprints left by our predecessors. And we will try very hard to meet and exceed the standards previously met. Our goal is to provide the finest seaplane service between Catalina Island and the mainland. To that end our entire efforts are directed. We really do care about you. We have a staff of seaplane pilots second to none. You will be flying with the best pilots in the business. Our maintenance program has been expanded and accelerated tremendously. We will settle for nothing less than the best in maintenance on our aircraft. And so, this is Air Catalina, Catalina's Experienced Airline. Come fly with us."

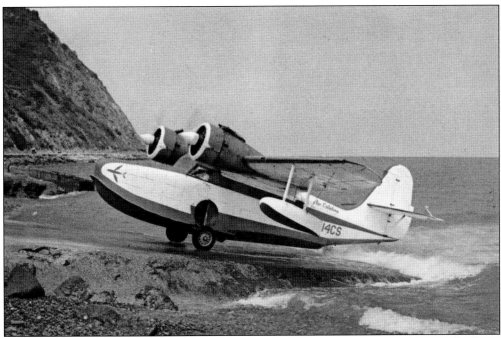

Air Catalina flew five Grumman Goose aircraft with a blue and white paint scheme and a flying fish logo painted on the nose of the craft. The airline operated between the Catalina Terminal in San Pedro, the Long Beach Airport, and Catalina's Pebbly Beach Airport. According to a *Catalina Islander* article on January 31, 1974, during the airline's first season of operation, "Air Catalina flew 120,656 passengers. According to Jackson Hughes, the airline's president, his firm carried 1060 passengers in a single day. The amazing total was flown in four planes."

Island resident Pat Johnson remembers a story about Brian Dawes, who was employed by Air Catalina: "We were going on road trips to the mainland for basketball. Brian was the manager of the basketball team. The planes were full, a maximum eight or 10 passengers with the jumper seat, but Brian was small enough that he fit in the forward bow and because he needed to get over with the team, he climbed into the forward baggage compartment and laid on top of the baggage." (Courtesy Roger Meadows.)

Air Catalina

Catalina's Experienced Airline

FLIGHT SCHEDULE

DEPARTURE TIMES

LONG BEACH AIRPORT

TO AVALON	FROM AVALON
8:00 a.m.	8:30 a.m.
9:00 a.m.	9:30 a.m.
11:00 a.m.	11:30 a.m.
1:00 p.m.	1:30 p.m.
3:00 p.m.	3:30 p.m.
4:00 p.m.	4:30 p.m.

CATALINA TERMINAL IN SAN PEDRO

TO AVALON	FROM AVALON
7:00 a.m.	7:30 a.m.
8:00 a.m.	8:30 a.m.
9:00 a.m.	10:30 a.m.
11:00 a.m.	1:30 p.m.
2:00 p.m.	2:30 p.m.
4:00 p.m.	4:30 p.m.

Schedules subject to changes & additions without notice
Please phone to confirm flight schedules & reservations

FARES — EACH WAY (Inc. Tax)
ADULT $11.95 CHILD (2 to 11) $8.00

INFORMATION/RESERVATIONS
Long Beach and South Bay Area............ 213 548-1314
Los Angeles Area...............................213 775-7107
Orange County Area............................714 827-7700
AvalonAsk Operator for AVALON 116

CHECK IN TIME: 30 minutes prior to departure of flight. Special charter flights and rates are available by advance reservation.

Longtime island resident Barkley Tree Jr. remembered that Air Catalina once played an important role in the birth of his daughter: "This was when my wife was pregnant with our first child. I was lying down and she came and shook me and said 'Bark, it's time!' I thought it was time for dinner, but it wasn't. So I quickly called the seaplane and made reservations. As we were getting on the plane an old buddy of mine, Bill Kilgour, pulled the plane around, slid his cockpit window open and said, 'Bark, we better get there!' We did get there, drove to Torrance and we were blessed with our first child." (Courtesy Roger Meadows.)

Mike McCormick fondly remembers flying with Air Catalina: "When I was a little kid, I used to fly the seaplanes all the time and pilot Vern McGee would let me sit in the co-pilots seat. We'd get ready for take off and he'd look over at me and say, 'Well, you've been up here enough, why don't you take the wheel?' I was about eight years old, I could barely see over the dash!" (Courtesy Roger Meadows.)

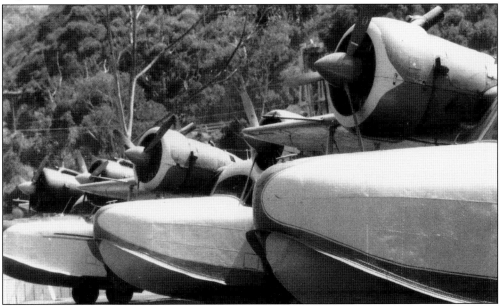

Air Catalina served Catalina Island for four years, offering multiple daily flights to Avalon and Two Harbors. At the height of the summer season, Air Catalina offered 28 round-trip flights per day. Pilot Bill Kilgour once said, "Each one of us makes more landings in a busy weekend than most pilots make in a lifetime." (Courtesy Dennis Buehn.)

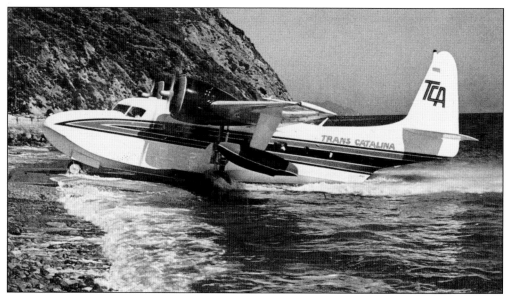

Trans Catalina Airlines inaugurated air service to Catalina Island in February 1978. The airline offered regularly scheduled flights between Long Beach Airport and Catalina's Pebbly Beach airport aboard Grumman Mallard aircraft. According to the February 24, 1978, *Catalina Islander*, "The planes differ from other craft used on the Catalina runs. They have three abreast seating, standing headroom and are extensively sound-proofed. The planes are operated by a two man flight crew and have 15 passenger capacity."

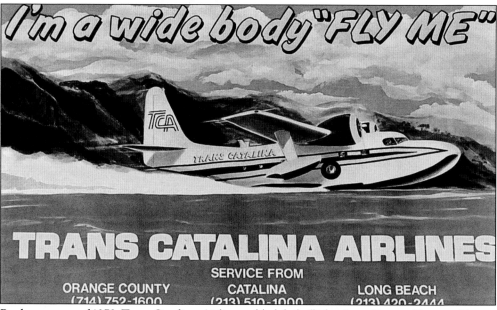

By the summer of 1978, Trans Catalina Airlines added daily flights from Orange County Airport and San Pedro to their service. The airline was a subsidiary of National Jet Industries of Orange County and was headed by Pres. Dan Hill. Hill was quoted as saying, "We consider our dependable, efficient service to and from Catalina Island the best ever offered to the public. We enjoy flying tourists, residents and business people to and from all the great attractions and facilities on Catalina Island." Trans Catalina Airlines operated flights to Catalina until 1981.

California Amphibious Transport was organized by businessman Dan Aikens in 1980. Aikens purchased a Grumman Mallard from Trans Catalina Airlines and commenced service from the Long Beach Airport to Catalina's Pebbly Beach airport. He later expanded the airline to include trips to the island's Airport-in-the-Sky with Piper Navajo aircraft. The seaplane service was short-lived, but Aiken continued to offer land-based plane service to the island under the name All Seasons Air Pacific.

There were several other airlines that served Catalina Island throughout the 1970s and 1980s. Eagle Airlines, California Seaboard Airlines, Coastal Pacific Airlines, Pacific Airlines, Piper Air Center, Valley Catalina Airlines, and Allied Air Charter all served the island on a regular schedule from various points throughout Southern California to Catalina's Airport-in-the-Sky.

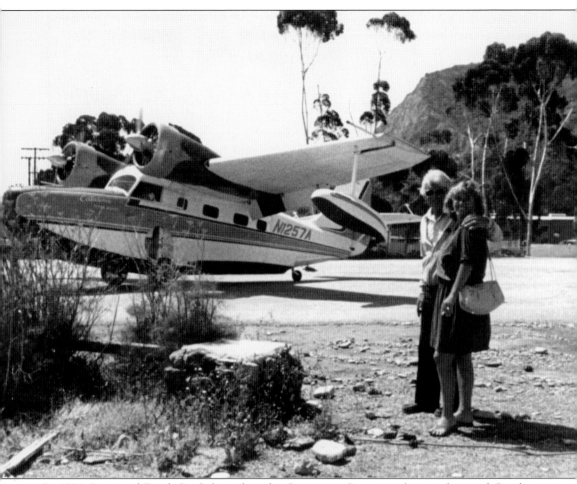

In 1984, Irene and Frank Strobel purchased a Grumman Goose seaplane and started Catalina Flying Boats. Frank, who loved seaplanes and worked for several of the island airlines over the years, saw a gap in seaplane service to the island and hoped to keep this tradition alive. Catalina Flying Boats operated between Long Beach Municipal Airport and Catalina's Pebbly Beach airport. The initial goal of the company was to offer freight service to the island, and according to Frank Strobel, "In three years of service to the island, we only missed one day of freight." In fact, Frank says, "even on days when the ocean was too rough to land on the leeward side of the Island, we would land on the windward side near Pinnacle Rock and taxi the plane to Avalon in high seas." (Courtesy Irene and Frank Strobel.)

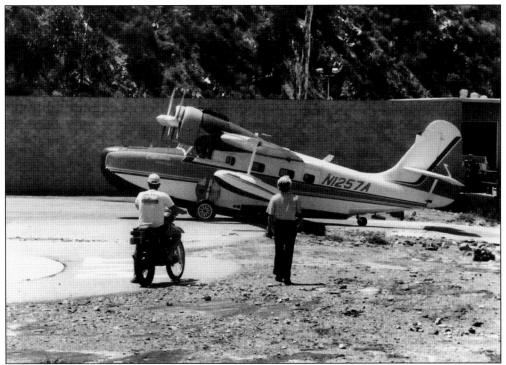

With its Grumman Goose, Catalina Flying Boats carried thousands of pounds of freight to Catalina Island each day. According to the *Catalina Islander* on March 14, 1986, "The Goose that flies daily to the Island from Long Beach carries high priority freight. It has brought up to 25,000 pounds on days in the summer, and is currently bringing up to 7,500 pounds a day during the winter months." Frank Strobel (right) is pictured here with David Phelps (left), who was an avid seaplane enthusiast. (Courtesy Irene and Frank Strobel.)

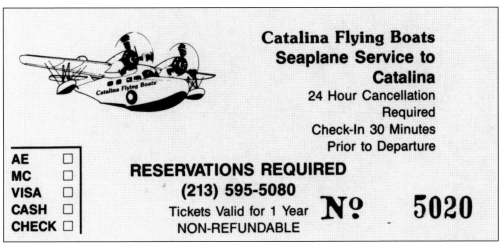

Catalina Flying Boats
Seaplane Service to
Catalina
24 Hour Cancellation
Required
Check-In 30 Minutes
Prior to Departure

AE ☐
MC ☐
VISA ☐
CASH ☐
CHECK ☐

RESERVATIONS REQUIRED
(213) 595-5080
Tickets Valid for 1 Year
NON-REFUNDABLE

N⁰ 5020

It was not long before Catalina Flying Boats ventured into passenger service as well as freight service. Island residents and visitors were excited to once again board a Grumman Goose for a quick trip to the island or mainland. Catalina Flying Boats flew passengers until the end of the summer season in 1987. It was the last airline to offer seaplane passenger service to and from Catalina Island. It was truly the end of an era. (Courtesy Roger Meadows.)

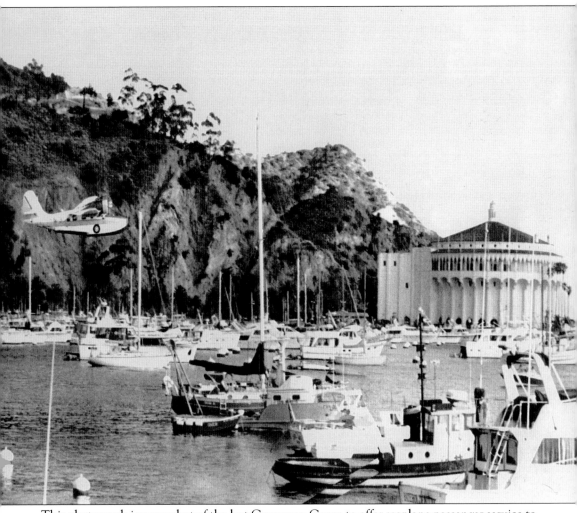

This photograph is a rare shot of the last Grumman Goose to offer seaplane passenger service to Catalina Island. Making an approach from Avalon Canyon to land outside the bay, the plane is only about 35 feet off the water. Irene and Frank Strobel sold Catalina Flying Boats in January 1987 to San Pedro businessman Steve Moller. Shortly after Moller's purchase, he added another Grumman Goose to his fleet and received contracts to carry U.S. mail and FedEx. Two years later, Flying Boats was sold to Steve Franklin of Aeronautical Services, Inc., who ceased the company's seaplane operations and opted to fly Beech 18s from the Airport-in-the-Sky to deliver the island's freight and mail. During the 1990s, in an effort to increase their capacity, Catalina Flying Boats purchased two DC-3 aircraft and began carrying millions of pounds of parcels, mail, and cargo each year. In 2006, Thomas Dean of Long Beach, California, purchased the operation. Today the company flies five million pounds of U.S. mail, UPS, FedEx, DHL, and general freight annually aboard two DC-3s and one Cessna Caravan. (Courtesy Irene and Frank Strobel.)

Eight

HELICOPTER SERVICE

Talk of helicopter service to Catalina Island began as early as 1959 when Los Angeles Airways, Inc., approached the City of Avalon with the intention to serve the island with a 28-passenger Sikorsky S-61 helicopter. Los Angeles Airways, a helicopter airline that served over 20 communities throughout Southern California, proposed to serve the island's community and visitors with regularly scheduled flights to and from several mainland points. Island residents were quite excited by the prospect of helicopter service. According to an article in the *Catalina Islander* on January 21, 1960, "The first flight over this town will mark a very important milestone in the future of Catalina Island. Safe, efficient, fast and comfortable transportation will put this island within easy commute from metropolitan areas." Los Angeles Airways continued to pursue their plans to provide service to the island until 1963. Unfortunately, this service never got off the ground, and Catalina's residents and visitors would have to wait until 1977 for regularly scheduled helicopter service. (Courtesy Santa Catalina Island Company.)

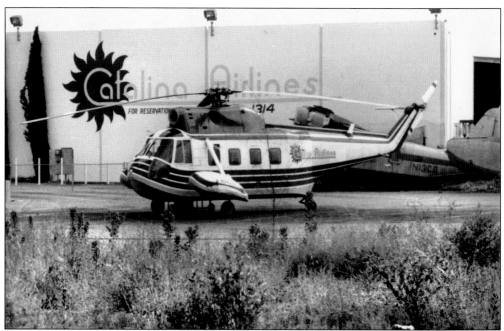

Catalina Airlines, Inc., began operations in 1973 with a fleet of Grumman Goose seaplanes. In 1977, the Goose fleet was temporarily grounded by the FAA, so the airline decided to use helicopters to maintain their scheduled service. Catalina Air Lines flew two Sikorsky S-62A helicopters and one Sikorsky S-58T. The helicopters operated from the Long Beach Airport and the Catalina Terminal in San Pedro and landed at a helipad constructed at the Pebbly Beach Airport site. The Sikorsky S-62A helicopters were amphibious, turbine-powered helicopters that carried up to 11 passengers. The Sikorsky S-58T was originally designed as a military helicopter, used extensively during the Vietnam War, and later converted for commercial use. (Both courtesy Briles family.)

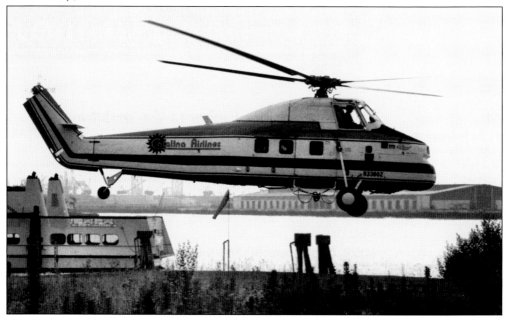

For two years, Catalina Airlines operated helicopters as well as their fleet of Grumman Gooses. However, by 1980, they abandoned their seaplane operation and concentrated on helicopter service. They added Bell 206-B Jetrangers to their fleet and offered daily service to the island. (Courtesy Briles family.)

Catalina Airlines provided regularly scheduled service to Catalina Island until 1981. The company ceased operations, but the airline's owner, Paul Briles, continued in the helicopter game. He founded Briles Wing and Helicopter, Inc., which still flies today, offering motion picture production assistance, sightseeing tours, and executive charters throughout Southern California.

HELITRANS

So Close, So Far Away

Spend more time on Catalina Island and less time getting there . . .

Helitrans, a subsidiary of Continental Air Marine, Inc., inaugurated helicopter service to Catalina Island in October 1981. Under the direction of general manager Chuck Rogers, the firm began operations with a fleet of Bell 206 Jetranger and Bell 206 Longranger helicopters. Helitrans operated between the Catalina Terminal in San Pedro and Pebbly Beach Airport, offering multiple flights per day. This Helitrans brochure reads, "We provide year-round shuttle service to Avalon, on scenic Catalina Island. Let us speed you on your way to enjoy the 'Mystery of the Island' in one of our modern jet-powered helicopters in smooth, quiet comfort. The beauty of the Island awaits you. Just 18 minutes from San Pedro Terminal by Helitrans jet helicopter service." The flight by air aboard one of Helitrans' Bell helicopters cost $44 one way or $80 round-trip. Helitrans also offered commuter cards for frequent travelers and commuters.

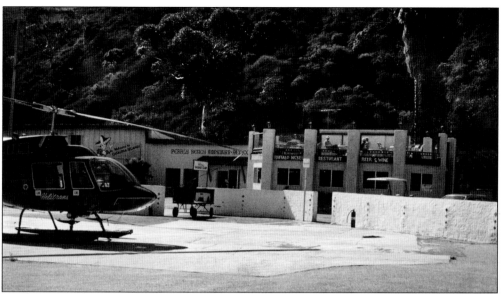

In 1984, controlling interest of Helitrans was purchased by Podesta-Moller and Associates of San Pedro, California. Under the direction of Podesta-Moller, Helitrans upgraded their fleet with two new 350-D Air Star helicopters. According to a June 29, 1984, article in the *Catalina Islander*, "Helitrans now has three helicopters on the San Pedro/Avalon flight schedule and can fly 48 passengers per hour. With their summer schedule of 13 flights a day each way, Helitrans will have the ability to fly 624 passengers per day." (Courtesy Santa Catalina Island Company.)

Helitrans Helicopter Service later ventured into the airline business, expanding their offerings to include regularly scheduled flights operating from Los Angeles International Airport, Burbank Airport, Orange County Airport, Long Beach Airport, and San Pedro. For a short time, it was possible to fly to Avalon from LAX, Orange County, Long Beach, and San Pedro. Helitrans continued their Catalina operations until 1991.

Island Express Helicopter Service began operations in March 1982 as a subsidiary of Island Resorts. At the time, Island Resorts owned and operated Las Casitas and the Pavilion Lodge and became interested in increasing the island's public air transportation. Island Express commenced operations with a Hughes 500 helicopter and offered a regularly scheduled service between Long Beach and Catalina Island. John Moore was the company's first employee and handled almost every aspect of the operation, including flying the helicopter. Moore, a native of Belmont Shore, California, gained his flying experience as a helicopter pilot with the U.S. Navy during Vietnam. After the war, John had been flying helicopters in Alaska for a couple of years when he got a phone call from Helitrans on Catalina Island about the possibility of a job. He traveled to the island to meet with Helitrans, but the job did not transpire. Luckily, at the same time, Island Express was just beginning operations, and John was hired as their first pilot. (Courtesy John and Patti Moore.)

When Island Express began operations in 1982, they went into direct competition with Helitrans. Traditionally, there were always two or more air service operations on the island, but helicopter service is such a small niche that Helitrans ultimately went out of business, leaving Island Express as the sole helicopter operation serving Catalina Island. (Courtesy John and Patti Moore.)

Island Express first operated from a grass landing field in front of the Hilton Hotel (now the Coast Hotel) in Long Beach. A landing pad was later built near the ocean liner RMS *Queen Mary*, which is permanently docked in Long Beach Harbor. Today Island Express has the only private heliport in the city of Long Beach. (Courtesy John and Patti Moore.)

For a short time, Island Express helicopters landed in front of the Catalina Laundry facility until a lease was obtained from the Santa Catalina Island Company to share the pad at Pebbly Beach with Helitrans. Pebbly Beach Airport (PBX) serves as the company's main office, from where they established a fast, reliable service that became increasingly popular with island residents and visitors. (Courtesy John and Patti Moore.)

Island Express purchased a Bell Longranger helicopter in 1982 that had a capacity for six passengers. With this helicopter, they offered multiple daily flights between Long Beach and Catalina Island and soon expanded their service to include San Pedro. In January 1984, Island Express opened a new office in the San Pedro–Catalina Cruise Terminal and began operating flights, which proved quite convenient for island residents and commuters. (Courtesy John and Patti Moore.)

In 1987, John Moore purchased Island Express and formed a partnership with Ken Putnam. Moore expanded his fleet and increased the company's marketing efforts with great success. In 1995, Island Express moved into a new terminal constructed at the Pebbly Beach Airport site, where it still operates today. Currently, the company flies four six-passenger A-Star helicopters that clock more than 3,000 hours combined each year. (Courtesy John and Patti Moore.)

Along with its daily air service to Catalina Island, Island Express provides service to offshore oil platforms in Huntington Beach and Long Beach and works with motion picture studios and with realtors looking for unique aerial shots of their properties. Island Express also offers special air tours of Catalina Island, downtown Los Angeles, and the coast of Southern California, as well as private charters. (Courtesy John and Patti Moore.)

Island Express Helicopter Service is a family-run business operated by John Moore and his wife, Patti. They have 21 employees, including five pilots who are all previous flight instructors. They maintain three terminals and a maintenance facility with three mechanics at the Long Beach Airport. John Moore considers Catalina Express, which operates boat service to the island, his biggest supporter because they work together to provide the best transportation possible for the island. According to Moore, "Many times when the weather is foggy and the helicopters cannot run, Catalina Express will go out of their way to offer their passengers another option for transportation to the island." Island Express just celebrated 26 years of service to Catalina Island, making it the longest running air service in Catalina's history. The 14-minute flight across the San Pedro Channel aboard an Island Express helicopter is a thrilling ride that everyone should experience at least once in their lifetime.

Nine

KEEPING HISTORY ALIVE!

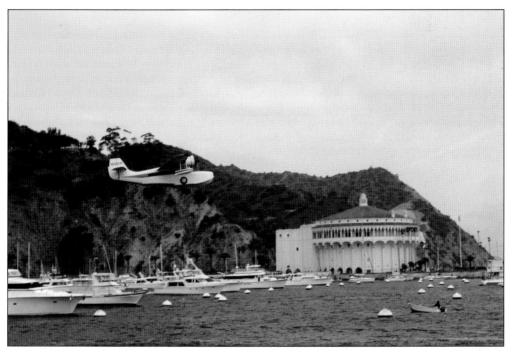

Many of Catalina's residents and visitors sorely miss the seaplanes that once served the island. They can still recall the distinctive sights and sounds of the planes and long for the days when the seaplanes were one of the primary modes of transportation for Catalina Island. In 1997 and again in 2004, several former airline employees and seaplane enthusiasts decided to get together and celebrate this important part of Catalina's history. The Catalina Seaplane Reunions were attended by former airline owners, pilots, rampers, dock boys, station managers, and seaplane lovers. The reunions featured displays of seaplane memorabilia, a lecture and book signing, home movies, and a party or two, which provided great opportunities for attendees to share stories and reminisce about the good old days. (Photograph by Al Gordon.)

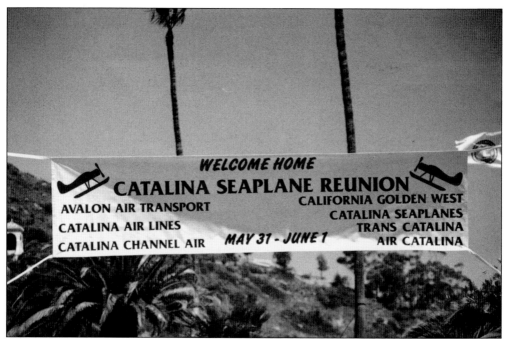

The highlight of the 1997 reunion was a visit from a PBY Catalina seaplane. The PBY was flown by its owner, John Wells, who was once a pilot for Catalina Flying Boats. According to a June 6, 1997, article in the *Catalina Islander*, "As part of the Catalina Seaplane Reunion, the Catalina PBY-5A, flew, dive bombed, buzzed and swooped all over Avalon. When it's not dive-bombing Island resorts, the Catalina PBY-5A and its water-dropping capabilities are used to fight California wildfires." Fifty years earlier, California Maritime Airlines served the island on a regular schedule with a PBY-5A Catalina seaplane. (Both courtesy Roger Meadows.)

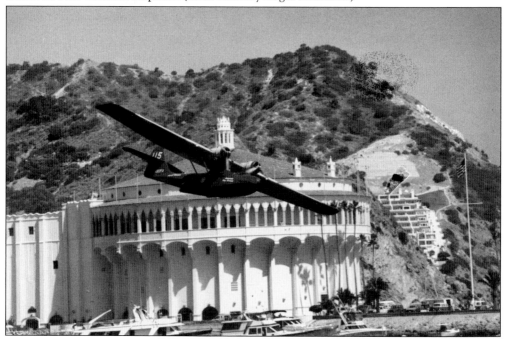

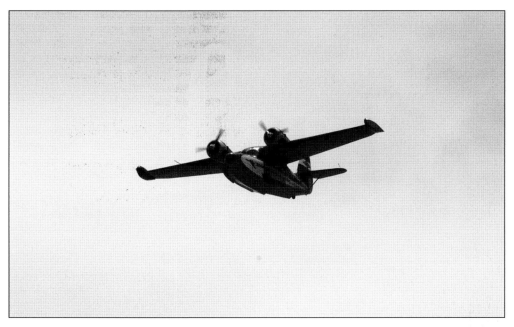

The first Catalina Seaplane Reunion proved to be so much fun that the group pledged to gather again. And they did. It was May 2004, and the highlight of the weekend's festivities was once again the seaplanes. Two Grumman Goose amphibians visited the island piloted by Dennis Buehn and Larry Tuefel. According to a *Catalina Islander* article from May 21, 2004, "Throughout the day, the skies were filled with the sights and sounds of the vintage seaplanes as they did 'flyovers.' Landing at the Island Express heliport, crowds welcomed the pilots and snapped shots of the seaplanes." (Both photographs by Al Gordon.)

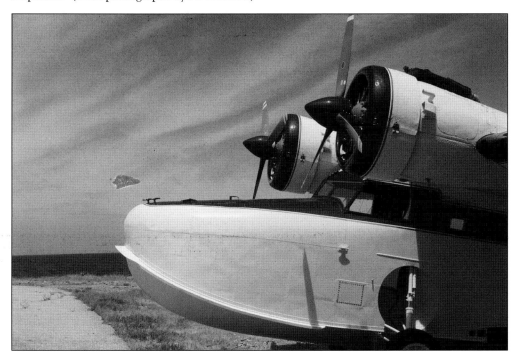

After receiving many requests from island residents and visitors for more information about the island's aviation history, the Catalina Island Museum opened a new exhibition honoring Catalina's seaplane history in 2004. Many people contributed to the documentation of this fascinating history; others donated artifacts from their collections and contributed their talents. Several of these people gathered to celebrate the opening of this special exhibit. Pictured from left to right are Roger Meadows, museum curator Jeannine L. Pedersen, David Phelps, John Phelps, Capt. Rex Cotter, and Stu Kilgour. The Catalina Island Museum is dedicated to the preservation and interpretation of Catalina's unique cultural history and is located on the ground floor of the world-famous Casino Building.

BIBLIOGRAPHY

www.catalinagoose.com

Captain's Log, Vol. 16, No. 4, December 1990.

Catalina Island Museum Archives

Catalina Islander, Avalon, California: 1914–2004.

Cotter, Capt. Rex. "Landing On Water: True Catalina Seaplane Stories." 2004.

Johnston, David L. *The Knights of Avalon*. Roseburg, OR: Horizon Line Press, 2004.

The Los Angeles Times, Los Angeles, California: 1911–1988.

White, William S. *Santa Catalina Island: Its Magic, Its People, Its History*. Industry, CA: Pace Lithographers, Inc., 1997.

———. *The Wrigley Family: A Legacy of Leadership in Santa Catalina Island*. Industry, CA: Pace Lithographers, Inc., 2005.

ACROSS AMERICA, PEOPLE ARE DISCOVERING
SOMETHING WONDERFUL. *THEIR HERITAGE.*

Arcadia Publishing is the leading local history publisher in the United States. With more than 4,000 titles in print and hundreds of new titles released every year, Arcadia has extensive specialized experience chronicling the history of communities and celebrating America's hidden stories, bringing to life the people, places, and events from the past. To discover the history of other communities across the nation, please visit:

www.arcadiapublishing.com

Customized search tools allow you to find regional history books about the town where you grew up, the cities where your friends and family live, the town where your parents met, or even that retirement spot you've been dreaming about.